The Self-Made Model
-
Success Without Agencies

Christie Gabriel

THE SELF-MADE MODEL – SUCCESS WITHOUT AGENCIES.

ISBN: 978-0-9850389-1-5 (print edition)

Cover Image © 2010 by Nadirah Bahar

Disclaimer

The claims and recommendations in this book are based on the authors' personal experiences and understandings. This book is not intended to provide medical, legal, personal security, or financial advice; readers should seek advice from qualified professionals before undertaking actions in any of these areas, and always use your own judgment and common sense. Minors should consult with their parent or guardian before undertaking any actions based on this book.

Acknowledgements

Special thanks to all the photographers, makeup artists, and stylists who contributed to this book. Photographs by: TH Taylor, Duke Morse, Nadirah Bahar, Vincent Michael, Red Sky Photography, Brock Lawson, Yvan Daddario, Moda Americana, and daFunk Photography. Makeup artistry provided by TH Taylor, Neda Stevic, Mickey Gunn, and Virginia McConnell. Styling and fashion design made possible by Michelle Evans, Neda Stevic, HMS Latex, Collective Chaos, House of Mob, and TH Taylor. Special thanks also to Ryan Gabriel for his invaluable graphic design skills, and Mary Miller for her editing insight.

Table of Contents

Chapter 1

Who Needs an Agency Today, Anyhow?

I admit it. I was a bit nervous as my flight touched down at Barcelona International Airport in September 2009. After all, this was the first shoot for a huge, internationally known brand that I had booked on my own. The photographer had kindly agreed to pick me up at the airport, and waiting to meet him in the crowded terminal, my nervousness increased. He had described himself as tall and dark, but that seemed to describe most of the Spanish men – along with "handsome." Finally, one of these men approached and introduced himself as Jake (not his real name). Knowing that he regularly shot for Vogue, Redbook, and many other top magazines, I wondered how safe his models were from his looks, charm, and fame.

Chatting in his surprisingly perfect English, Jake drove me to the center of Barcelona's old city, where an apartment had been rented for me. It was a charming mix of modern and antique, wood floors and high ceilings, with big windows overlooking the narrow streets. The following day that picturesque view would be the setting for our promotional campaign shoot for Cartier S.A., the 150-year-old French jewelry firm (and inventor of the wristwatch).

The next morning found me on a rooftop, done up in a vintage Hollywood look and wearing $500,000 worth of diamond jewelry. Barcelona, hot and humid in the summertime, is lovely in fall – at least if you're not standing

1

half-naked on a ledge six stories up in the air. Despite the bright sunlight directed back at me by the surrounding reflectors, I was freezing!

Aside from my goose bumps, though, it was great fun: a highly professional team – a makeup artist, a hair stylist, Jake, his assistant, and the art director – working skillfully against the backdrop of old stone buildings and red-tiled roofs. After only a day, Jake and the art director were happy with what we had shot. The client had offered to let me keep a couple of the pieces I had been wearing, which was a sweet gesture.

At the end of the shoot, Jake asked if I would like to shoot on spec for some of his magazine clients. Knowing who those magazine clients were, I accepted on the spot.

The next day when I arrived at Jake's studio, I found a dozen people milling around. In addition to Jake and his assistant, there were makeup, hair, and wardrobe people, art directors, and a couple of other models. I was soon at the center of a whirlwind of activity. We shot two looks: lingerie in studio and again on the rooftops, and then a more classic fashion look on the streets. Because of the great team, a shoot that was to have taken two days was finished in five hours. In the end, Vogue España and Maquillage Magazine, as well as some other European magazines, picked up the pictures from this day.

Through all of this, I spent my evenings exploring the narrow, winding streets of old Barcelona with Jake, and eating delicious seafood. Just for laughs, and to be able to say I had done it, I even made time to splash around in one of the town's many large, ornate fountains with another model, much to the delight of the locals.

I also kept up with my networking. I lined up another job in Spain, posing for a fine-art sculptor, a type of job whose posing requirements can either be cake or pure hell. Luckily, for this one I only had to sit curled up on a garden bench. The resulting work ended up selling for quite a lot of

money. I also secured future work with Jake and his team, and have since done shoots with them in Barcelona, Madrid, and Paris.

At the end of the week, I returned to Chicago for a little R&R before my next trip – to Ireland, to shoot for a book of figure nudes by yet another photographer.

Fun and exciting? Yes. But the best part is that I landed, vetted, and performed all this work myself, using the Internet and knowledge gained working as a model in all parts of the industry for the last dozen years. I didn't have to pay a big chunk of my wages to an agency, and I made contacts that are likely to get me similar work in the future.

Ten years ago none of this would have been possible. Back then, if you weren't signed with a big agency and living in one of the four major US fashion markets (New York, Chicago, LA, or Miami) or one of the foreign fashion capitals (Paris, Milan, London, or Tokyo), you couldn't have a modeling career. Casting directors, clients, and photographers found models through agencies, and the only jobs you could get without representation were either scams, low-paying (as in $0-15 dollars an hour), or pornography.

If you want to be a model, there's good news and bad news here. The good news is that the whole world of modeling is open to you in a way it has never been open before. The bad news is that you can't just stumble into a successful modeling career: you need more knowledge than ever before to make it – knowledge that it usually takes years in the industry to gain.

That's where this book comes in. I've spent those years in the industry, and I've seen a lot of the most important industry changes as they happened. I think this gives me a better idea of how things work than most people – the same way you would have a better idea of how a house is put together if you watched it being built rather than

coming around to inspect it after it's finished. In this book, I lay out this knowledge for you.

This book focuses on the two main skill sets you will need to be a success as a model: modeling skills and business skills. It discusses these skills in roughly the order you will need to know them as you go from newbie to seasoned, successful professional.

On the modeling side, it tells you what you will need in your "kit," how to learn to pose, what to do when you're on set, and the five unbreakable rules of modeling. On the business side, it tells you what online and offline tools you need to market yourself, how to make your first contacts, how to vet jobs and negotiate pay, and how to keep your clients coming back for more. For those of you who would still like to try out the agency route, there is also an Appendix telling you how to land and retain agency representation, and how to make it work for you.

Chapter 2

The New Open Market

The industry has evolved since the days when the modeling agencies reigned supreme. You need to know about these changes (both good and bad) in order to take full advantage of this more open market. This chapter discusses these changes and what they mean for your modeling career.

The Open Market

The Internet has turned the tables in favor of freelance modeling. Agency representation can still come in handy, but it is no longer necessary for a successful career. Like the bricks and mortar bookstores being driven out of business by Amazon.com, the formerly all-powerful agencies are under pressure, and may even be at risk of extinction. Unless you're a Heidi Klum or a Gisele Bündchen, today's agency-dependent castings are cattle calls that may have upwards of a hundred models in attendance, a symptom of the fewer and fewer agency jobs available. Agencies are being cut out because clients are willing to book the models they find self-promoting online. In other words, unless you're a supermodel, you may fare better without an agency. Let's look at the upside—and then the downside—of this newer, more open market.

The Good News

Networking Is Easier
A decade ago, even if you were signed with a top agency and getting regular work, building a reputation was a long and laborious process. If you wanted to network, you had to attend "after-parties" and visit exclusive (and expensive) hotspots. Trying to negotiate with powerful counterparties while half-crocked and exhausted is just not a good business strategy. Today, you can stay sober and negotiate online, or even set up a quick business meeting at the local Starbucks. After the deal is closed, you can go to the wild parties without feeling the need to accomplish anything more serious than having fun.

Direct Access To Clients
Now that models can book work directly, the relationship between model and client, and even model and photographer, has changed. In the past, a model might have as little as 30 seconds to convince a casting director to hire her. With so little time to make an impression, you really had to wow them, especially if you wanted to not only get the job, but get them talking about you to other insiders.

Today you can email, Skype, and Facebook with these people, and they can look at your portfolio anytime and at their convenience. Odds are you're already using the same industry and social networking sites as they do, so you can always say a quick hello to make sure your face doesn't fade from their memories. Google alone is enough to spread the word about who you are and what you've done. All this helps you target your marketing much more effectively.

Vetting Is Easier
Vetting prospective jobs is mandatory if you are going to represent yourself. Luckily, it is also extremely easy. A quick web search will get you pages of information about a client or company. After doing that, hit the networking

sites to contact models who have already worked with the individuals in question. As long as your BS-meter is on, you can almost always tell whether a job offer is legit and safe.

Technology Makes Everything Easier

Technological advances have had ripple effects far beyond marketing as well. For one thing, improvements in photography equipment have produced large numbers of hobbyist shooters. This has, in turn, increased the demand for models at all skill levels.

Once you start working, you'll find that cameras are often tethered to a big screen that displays each photo seconds after the shutter clicks. This means that models can now often see problems in real time. If a hair is out of place, or a pose makes it look like you're missing a limb, or you blinked at a crucial moment, you can adjust to eliminate the problem for the next shot.

A pimple or bruise used to be grounds for a lecture on set, due to the expensive and time-consuming nature of archaic retouching. But today's post-processing handles imperfections efficiently and affordably. Of course, this can spell trouble when clients book a model on the strength of an online portfolio that shows great skin and a perfect figure, only to get an unwelcome surprise when she shows up in an entirely different body with stage 4 acne. Don't be that girl.

The Not So Good News

So what's not to like? It's easier than ever to enter the modeling market, to network and build your reputation, and to erase your imperfections. On top of all that, you're no longer just a clothes hanger, but are often encouraged by hobbyist shooters to contribute your own ideas to shoots. Unfortunately, there's no such thing as a free lunch. Every one of the good things I've mentioned has a downside.

Too Many Models

The first and most obvious problem is that while you have a direct line to casting directors and photographers on the web, so do thousands of other models. You can build a website, but it has to stand out from the hundreds or thousands of others touting the charms and talents of your competitors. You can describe your skills and experience, but a hundred less-qualified models may be able to put on a front that makes them seem just as good as you.

This has created a massive oversupply of models. A decade ago I never had to compete with "wannabes" for lucrative commercial jobs; now some of these girls will work for free simply for bragging rights – and it's sometimes hard for the client to tell over the Internet just how unskilled many of them are until it's too late.

Threats To Your Image

The second downside is that the web can just as easily damage your career as build it. You have to manage your online image and be alert for threats to it. For example, you may make good money and enjoy the creativity of edgy nude work, but high-paying commercial clients may shy away if a Google search on you pulls up racy images. Scammers and wannabes may set up websites or blogs pretending to be you, and amuse themselves by saying outrageous things that are then attributed to you. Even without these nasty problems, managing your online image can be complex and time-consuming.

High Expectations

Third, photographers now often expect you to be competent in all posing styles (fashion, beauty, commercial, glamour, and fine art), and to take on the role of makeup artist, hair stylist, wardrobe stylist, and often even art director. I never had to do my own makeup or hair prior to the online modeling boom. Now I have to do both on 70% of my shoots. An adaptable and skilled model can do all this, of

course, but I look back fondly to the days when a full team was always provided.

A typical budget back then was $1000-$5000 per day for the model, plus another $2500-$5000 for makeup, hair, and wardrobe stylists, plus some ungodly amount for the art director. Nowadays you may be expected to do the jobs of all those people for less than $1000 per day.

Unfortunately, in a saturated market, we are in no position to turn down many of these multi-responsibility offers. Too often these days if a model tries to negotiate even a little bit, the photographer or client will simply go to some less qualified model who claims to have the needed skills. The only good news in all this is that the clients and photographers who fall for such claims learn quickly that you get what you pay for.

Business Demands

Fourth, unless you go the inefficient agency route, being a model today means also being a businessperson with savvy in a wide range of areas. You are your own booking agent, travel agent, business manager, and accountant. You set your own rates, decide which jobs you should take and which you should turn down, evaluate contracts and release forms you are asked to sign, do your own public relations, manage your own "brand," network with industry people, and a hundred other things. If you are looking for a simple career with minimal demands, you may want to look elsewhere.

Low Social Esteem

Fifth, the playing field leveled by technology and the accessibility of the Internet means models are held in lower esteem than in the past. People used to view modeling as a vocation open only to those with unearthly beauty and a 00 dress size. That flattering perception is being transformed into its equally unrealistic opposite because now anybody can claim to be a model simply by posting photos

(pornographic or not) online. With so many of these "models" clogging the airwaves, many people assume that anyone claiming to be a "model" is either a poser, a porn-star, or both. Now when asked what we do for a living, many of us fall into coughing fits or try our best to look like fry cooks. Unless we have our book or comps with us (in which case we come across as arrogant), people assume that we're just playing online make-believe and then bragging about it to our friends.

Happiness in the Open Market: Know Yourself

Understanding the advantages and disadvantages of today's open market is a first step in deciding whether modeling is for you. Next you need to evaluate whether your reasons for wanting to be a model are conducive to a successful, happy career.

Chapter 3

Reasons and Expectations

Your reasons for wanting to be a model play a huge role in whether you will be happy or disappointed in this field. If your expectations are unrealistic, you are likely to crash and burn. If they're reasonable you'll have a much better chance at success.

Bad Reason #1: It's Easy Work!

Think again. Exhaustion is a more common occupational hazard for successful models than boredom. Modeling is physically demanding, and requires concentration, adaptability, alertness, and an ability to wear the most uncomfortable outfits on the planet, often in unpleasant weather. In a typical daylong fine art shoot you will hold one difficult pose after another for hours on end.

In a recent shoot with one of my favorite photographers, I spent the first hour contorted in a dirty kitchen sink; the next hour I stood on tiptoe in five-inch heels while half-squatting, thrusting my hips far out to the side – all the while looking cool and sexy, of course. By the end of the shoot my legs were trembling and I could hardly stand. Posing well often leaves your muscles so sore and knotted that you need to add massage therapy to your business expenses.

An advantage of freelancing online is that clients thousands of miles away can dangle work – and money – in

front of you. If you're lucky, they'll ask you to travel to Paris in the spring or Barcelona in the fall; on the other hand, you may get Atlanta in the summer or Toronto in the winter. Either way, a steady diet of air travel can be exhausting.

It's not only the physical aspects of modeling that are hard work. As a freelance model you will have to scout work, research references, network, charm clients, keep up with industry developments, keep track of your business expenses, and dozens of other things. If organization isn't your strong suit, you'd better get good at it quick.

Wanting to be a model so you can have an easy life is just asking to be disappointed.

Bad Reason #2: I'll Be Famous and Admired!

Having dismissed the Lazy as likely model prospects, we now come to the Narcissists. These people want to model so they can be Celebrities. They imagine themselves flashing smiles from Hollywood's red carpets, dancing with the stars in St. Tropez, or commenting on some designer's new fall lineup.

Well, it could happen. But what are the odds? The top freelance modeling website today has about 500,000 members, about half of them "models." Of these 250,000 models, probably no more than 20% are getting paid work. Still, that means you're competing against 50,000 freelance models, not to mention thousands of others represented by agencies the world over. Now, how many celebrity models can you name? Ten? Maybe fifteen? Anyone who thinks these are good odds should think again.

Your Relationships. Not only is modeling unlikely to make the world love you, it may even disrupt the relationships you already have.

Be prepared to deal with jealousy issues. Other people will be more interested in you when they learn that you're a successful model – and the more successful you get, the more interested they'll become. This may not go over so

well with your significant other. Some of your friends may also become jealous of your success and withdraw from you.

With your family, the dynamic is somewhat different. Especially if you shoot nudes, certain relatives may decide to view you as either a strayed lamb or a black sheep.

Once these issues arise, a lot of work may be required to resolve them. Your family and worthwhile friends will usually come to terms with your profession in the end. With significant others, the outcome is less certain. If he/she can't keep the jealousy in check, you may have a decision to make: forget him/her or forget your modeling dreams.

Bad Reason #3: I'll Be Rich!

This career attracts many who believe that riches will be theirs if they can only make it to the catwalk. Let's look at the facts. According to the U.S. Bureau of Labor Statistics, the average annual salary for professional models is $42,500, the top ten percent of whom make an average of $60,000 a year. These income levels are roughly the same as car mechanics, and $10,000 - $12,000 a year less than elementary school teachers and real estate agents. While it's true that a few models earn tens of millions of dollars a year, the Greedy also should consult the law of averages before deciding on modeling as a career.

Better Reasons

Knowing this reality, why would anyone ever want to take up modeling – which is difficult, tiring, sometimes low-prestige, and often only moderately profitable?

Well, because it's fun, interesting, and a great creative outlet. Besides who wouldn't love to be their own boss, and meet lots of interesting people? You can also make a good living at modeling too if you work smarter and harder than your competition. Your career will be much more fulfilling if you pursue it for the following reasons:

13

Good Reason #1: Self-Expression and Creativity

A good model is much more than a prop: she is part dancer, part actress, part mannequin, and part mime. It's hard to get a feel for just how satisfying this can be until you actually start working. Successfully conveying emotions and telling stories makes all the hard work and aching muscles worthwhile.

And if you still love to play dress-up, modeling will likely scratch your itch. My inner little girl rarely complains that she doesn't have enough fun.

Good Reason #2: Excitement and Glamour

Despite the hard work, long hours, and stiff competition, modeling can be an exciting profession even for us non-celebrity models. For one thing, once you break out of the ranks of the wannabes and start making a reputation for yourself, you'll start getting opportunities to work with highly skilled photographers, art directors, and designers.

And if you like to travel, you're in luck. Clients and photographers who want your look will fly you to beaches, deserts, cities, and jungles to photograph you. It's especially nice when a client is picking up the tab in some exotic location you would never have gotten to visit otherwise. As a working-class Midwestern girl, I doubt I would have ever had the chance to fall in love with Paris if it hadn't been for my career.

As an established model you'll also get invited to some pretty wild parties, and you may even meet some truly beautiful or famous people. While their charm can wear thin, going to an occasional bash where no expense has been spared is a nice perk.

Good Reason #3: Being Your Own Boss

Being a freelance model puts you in charge of your own career. You – rather than some employer – make the decisions leading to your success or failure. You keep every dollar you earn (after taxes), so your income depends

directly on your own hard work and creativity instead of someone else's evaluation of what you are worth. You set your own schedule and work pace, and you can't be fired for taking a week off when you need some R&R. Best of all, the sky's the limit: you can rise as high as your talent and persistence take you. You don't have to worry about corporate bureaucracy or whether there are "open positions" in the career areas you want to pursue.

The Real Requirements for Being a Model

Many people never follow their dream of becoming a model because they don't fit the outdated mold known as "The Model Look." While it is true that high fashion models are often required to be at least 5'9" and more or less 34-24-34, even these rules are not as strict as they used to be. Besides, the runway isn't the only way. You still need good skin, teeth, hair, and nails, but you don't need a specific "model look." Even the website of such a traditional modeling agency as Elite only requires applicants to be tall: "Between 5'8" to 6' Tall (Without Heels)."

This broader view of beauty has given rise to many "niche modeling" markets. Plus size models are increasingly needed for commercial work. Fashion advertisers now often turn to odd or unique-looking models to grab the attention of younger consumers who are bored with "traditional" beauty. Older models are needed to keep up with the aging of the population. And many fine art professional and hobbyist photographers have an inexhaustible appetite for the unusual, imperfect, and even ugly in models. (Niche markets are discussed in detail in Chapter 11.)

Do You Have To Be Classically Beautiful?

It's true that if your genes have packaged you to match society's idea of beautiful, you initially have a big advantage. Be warned, though, that if you don't couple your lucky DNA with hard work and career smarts, you will lose

out to competition that is less physically blessed but more driven.

Remember that in the entertainment, art, and advertising industries, beauty is a construction: fantasies made of carefully designed and photographed sets, scenes, lights, clothes, makeup, and someone to put in them. Depending on the kind of beauty desired for these fantasies, different types of models will be needed – sometimes quite different from what you might expect.

When trying to guess how your appearance will drive your career, don't rely solely on your own opinion. At the beginning of my career, I thought of myself as repulsive. Despite reassurance from my bookers, designers, casting directors, other models, and the public, it took me a long time to get over this self-image problem. In fact, most pro models I know don't think of themselves as even pretty. At the same time, don't get discouraged if your appearance is sometimes not appreciated. Some of today's supermodels were turned down by many agencies before rising into the top ranks.

Because beauty is elusive and subjective, get a second – and third – opinion about your looks, though not from anyone who wants to charge you money (like bogus "modeling schools") or has some other incentive to flatter you. If many different people say you should be a model, this is one sign that maybe you should, since these people make up the public to whom models must appeal. You also need to get an objective idea of how you look in photographs, regardless of how attractive you may be in person. Being pretty isn't synonymous with being photogenic.

Do You Need To Be Young?

I'm writing this in the last few months of my twenties, yet like many other models of the same age, my main problem is scheduling all the work I'm offered! Don't let the

outdated idea that you have to be young to be a model discourage you. Many women in their thirties and even forties are still making a good living at it.

Chapter 4

A Model's Bag of Tricks

There are a plethora of seemingly random things you need to be a professional model. In fact, it takes me three full chapters to cover them all! Lets start with what goes in your bag.

A Beginner's Kit

A traveling model I know of drives around the country in a Honda midsize bursting with suitcases. Photographers drag these into their studios, where she unpacks enough outfits and cosmetics to run a Broadway musical. She has accumulated these things over years of modeling and hasn't let go of any of them.

A model's kit need not be so extensive, especially when she's just starting out. Your main resources are your brain, body, and face. But there are certain basics that you should start with as a minimum. You'll probably find that as a normal, healthy female you already have a lot of this stuff. What you don't have you can get for a reasonable cost. (You should probably plan on laying out about $200 a month to begin building your kit.)

Wardrobe

Some shoots – especially the commercial shoots you will start to do as your reputation grows – will provide wardrobe. On the other hand, many photographers expect

you to arrive with all the wardrobe you need. The trick is to figure out in advance what is wanted. For professional gigs, do this by reading the call sheet; for informal jobs, you may need to contact the photographer (which you should try to do well in advance).

If I'm expected to supply wardrobe, I'll estimate how many outfits to bring based on the length of the shoot. I generally try to bring about 3 outfits for each hour of shooting time. So if I'm told to bring wardrobe for a 2-hour street-fashion shoot, I'll bring at least six outfits that fit that theme. If the shoot will only be about an hour and a half long, four mix-and- match outfits should suffice. No matter what, I always bring plenty of shoes and accessories.

Given the frequency with which models are expected to supply their own wardrobe today, there is a minimum "classic" wardrobe set that every model should have. It includes:

- One or two little black dresses
- A couple of pairs of form-fitting jeans
- A few wife-beaters, including a white and a black
- A pair of black high heels
- A pair or two of black thigh-highs and black pantyhose
- A solid-colored bikini
- A neutral-colored lingerie set (white or black)
- A flesh-colored thong and bra set

These are "classics" because they work for most people and have stood the test of time. Black, white, and most strict neutrals (beige, brown, gray) work for many different themes and looks, and should be well represented in your wardrobe. If there's something unusual a photographer or client wants you to wear, they will usually provide it themselves – but always check to be sure.

A working model should have plenty of personality pieces from her everyday wardrobe that she can bring to shoots when needed. (Freelance modeling would be a lot more expensive and less fun if you had to keep your shooting and everyday clothes segregated.) The exception to this is shoes, which quickly start looking ratty if you wear them off set. What this means, regrettably, is that in most cases you have to keep the shoes you use for shooting separate from your personal stash.

Of course, a model's clothes must look good on her. This is another area where you should listen to your friends, but there are also certain established guidelines. The kinds of clothes that look good on you depend primarily on your body shape, while the colors that flatter you depend on the undertones in your skin. If you're not familiar with these general rules of cut and color, study up.

When I'm really booked up with hobbyist photographers (who often don't supply wardrobe), I buy 2 new or gently used outfits and one new set of lingerie every 10 weeks, give or take. There's a constant need for new thigh-highs and accessories (costume jewelry, hats, bags etc.). I'll also spring for a new pair of heels or boots every season. This is less expensive than you might think. A frugal model can keep up her wardrobe for as little as $50/month. As you build your wardrobe kit, the price of keeping it current will steadily decrease.

Cosmetics and Hair

Most people wrongly assume that models simply pose, walk, and radiate; things like makeup and hair styling seem almost as far outside their area of responsibility as publicity and fighting with clients over past-due payments. As I hope you're beginning to realize, nothing could be further from the truth. Market pressures have driven the skill sets models must possess higher and higher.

Most aspiring and hobbyist photographers don't have the resources to provide makeup artists ("MUAs") or hair stylists, and even some commercial clients don't see why they should when so many models offer these skills "free of charge." You'll undoubtedly do shoots where makeup and hair are provided, especially as you break into the higher levels; however, even very experienced models today are frequently called upon to do their own. As a beginner you should learn to handle these services at a semi-pro level at least. I took over a year off full-time modeling to get licensed as a professional esthetician and MUA, and I have never regretted it: it's a skill I use constantly.

Cosmetics. Before you even think about makeup, you should buy and use a good quality cleanser (this is highly specific to skin type so once you find one that works for you, stick with it until your skin condition changes), exfoliant, moisturizer, and sunscreen. Never forget either that getting enough sleep and eating right, not to mention guzzling large quantities of H_2O, can make the difference between good and bad skin. Makeup can do wonders, but it's even better when the canvas is already in good shape. That being said, a model's basic cosmetics kit should include:

- A lip gloss palette
- An eye shadow palette
- Mascara
- Foundation and concealer
- A soft blush and/or bronzer
- Powder
- A couple of brushes
- Plenty of Q-Tips
- False eyelashes and glue
- Eyebrow powder
- Eye- and lip-liners (not essential, but strongly recommended)

- Several neutral nail polish colors
- A small nail care kit, tweezers, cotton balls, and makeup remover

If you want to really splurge, I can attest that a Temptu airbrush system is well worth the money.

Your makeup skills should include the ability to do a good base, cover imperfections with concealer/foundation and powder, and a basic understanding of contouring (adding darker colors will recede areas/features and adding lighter colors will bring them forward). Generally, you should start off with as little makeup as you can because you may need to apply more layers as the shoot progresses. Ask your photographer for his preferences before increasing your makeup between looks.[1]

You should also know that many photographers dislike mineral-based makeup because it is highly light-refracting, tends to show up quite differently in photographs than in person, and can also make skin look gray or sallow.

Things to remember when applying makeup. Too much blush can make your cheeks look jowly, and heavy powder may accentuate fine facial lines. In fact, powder in any form should be avoided if possible, unless you're super-oily. Instead of powdered blush, use one with a cream base; for eye shadow, consider an eye pencil or cream palettes. If you must use powder, just apply a light layer to the t-zone (forehead, nose, and chin).

To enhance the fullness of your lips, opt for lighter shades of gloss. To increase this effect, be sure that the very

[1] No doubt some readers will be offended that I generally refer to models as "she" and photographers as "he." I'm simply using the pronoun that corresponds to the majority of the members of each occupation to avoid the awkwardness of repeatedly saying "he or she" and "his or her." I mean no disrespect to either group.

center of your lips is a shade or two lighter than the outer corners.

Thin eyebrows age a face tremendously, so be careful not to over-tweeze. This is the one area where you should always use powder: brow pencils pull out hairs, which can cause thinning. Pencils also create a harsh line that isn't always flattering. Choose a brow powder that is a shade or two lighter than your eyebrows. For example, my brows are almost black so I fill them in with a medium brown powder.

There are a huge variety of makeup and hair products on the market, but in general I've found that the cheaper brands are just as good as the higher-priced stuff. This is one area where you can save money by shopping wisely. I probably spend about $50 a month on all my hair, nail, makeup and skin care needs.

Part of keeping these costs down is using self-help. Get a nail file, nail polish remover, and some basic nail colors like red, light pink, black, and clear, and a top-coat, and save $50 a pop for manicures. Tweeze your own brows and other facial hair, and shave your own legs, underarms, and bikini zone. (Just remember to avoid razor burn and ingrown hairs: shave in the direction of the hair growth rather than against it. After shaving, apply an unscented lotion in the direction of the hair growth.) Skip the gym membership and get yourself some hand weights and a pull-up bar, or a Pilates book and mat, for a total investment of $25, and go jogging in your neighborhood.

Of course, there are some things you should get done professionally. For example, if you must have a tan, splurge on a professionally applied spray tan, which won't ruin your skin or give you cancer (like the sun), or make you look like a hotdog (like many over-the-counter canned tans).

Hair. The professional's hair kit should include:

- A brush
- A fine-toothed comb (or pick depending on hair type)
- Hairspray
- Hair gel
- A curling iron
- A blow dryer
- A lot of bobby pins and hair ties

Personally, I feel that it's best to stick as close to your natural hair color as possible. This both cuts down on upkeep costs and tends to look best because it looks natural. As far as keeping your hair in top shape, a simple trick to add shine and smoothness is to just switch shampoos the day before a big shoot, and then go back to your regular stuff the day after. It never seems to matter what shampoo I switch to for the day, as long as I don't use it often.

Chapter 5

Getting Set Up Online

So without an agency and an efficiency apartment in New York shared with half a dozen other girls, what do you do? This chapter will cover the tools you need for online marketing, and how to use them. But whether or not you follow my advice, be aware that you need to be ready, willing, and able to learn and adapt as you go. The modeling industry is dynamic and evolving, and part of being a successful model is staying on top of the changes in real time.

Photographs

Your one indispensable resource for online marketing is your pictures. While high-quality professional photographs are ideal – and you should try to get some as soon as you can – starting out you should at least get some decent snapshots in minimal makeup, preferably just foundation, mascara, and lip gloss. These should ideally include a head shot, a profile, a three-quarter-length shot, and a full-length shot that shows your body shape. You should consider also getting a similar set of shots with a more done-up look.

These pictures don't need to be elaborate or professional to start out with; what you do need is photos that show what you look like at your best. An afternoon at the park with a friend and a cheap digital camera can often

produce several usable shots. Try to avoid amateur photographic mistakes, like full-body shots taken from high up so that your legs look short. Trying for artsy angles and edgy lighting is not a good idea unless the friend wielding the camera is a professional photographer; at the other extreme, you don't want pictures of the back of your head taken at the family barbecue. The idea here is to have some clear, ordinary pictures that show what you look like when you're cleaned up, lightly made up, neatly dressed, and relaxed.

Don't hesitate to replace pictures and discard the ones that don't work in your online portfolio. Half a dozen clean shots will be just enough to give professional shooters an idea of your look. After you get their attention, you'll be able to build a better book.

High-Speed Internet, Online Portfolio, and Your Website

It's difficult to take advantage of the instant connectivity and global reach of the Internet if you're not hooked up to it, or are only hooked up by a tiny little thread. Photographs are notoriously byte-greedy. If you have time to vacuum while the latest set of photographs from your favorite photographer is downloading, you need to upgrade your connection speed. Yes, you may have to pay fifty bucks a month for broadband, but after eating, this is probably your most worthwhile expense.

Modeling Websites

Online you're going to live in New York – and Paris and Tokyo and every other place in the world – be your own personal agency, and get more attention than any outside management could ever get you.

Of course, to sell your particular product – your modeling – you'll need a place on the Internet where people can go to admire your portfolio (or "port"). Many specialty "modeling websites" will host your portfolio for free or a modest fee.

While these sites have a tendency to appear and vanish as quickly as the morning dew, a few have been around for a number of years, and show symptoms of staying for a while longer. (The largest and most active is currently Model Mayhem, which went live in 2005 and claims to have about 500,000 members, about half of them models, and the other half photographers, makeup artists, Photoshop wizards, and assorted others.)

Joining as many of these sites as possible will, at the very least, increase your Google association with modeling, and may also increase your odds of getting on the right person's radar screen. As you gain experience, you'll be able to focus your time and energy on the ones that are getting you the most work and interest. With persistence and diligence these sites can pay off: in recent years, over half my own work has come through modeling websites, and this is also true of many of my professional model friends.

In addition to a place to put your photo gallery, most modeling websites give you a front page on which to promote yourself through text, testimonials, web links, etc. The impression you make in this "profile" section of your online portfolio can also influence prospective clients, so you should write it carefully.

Should you use your real name? The answer is, it depends. If you want to be taken seriously in the fashion and commercial sectors, you should use your real name, or at least an alias that sounds like a real name. If you're content with being strictly "alternative," or you want to do nudes but don't want it shoved in your family's and friends' faces all over the Internet, use an alias. Another way to handle this is to have two separate ports on each website, one nude/alternative, and the other "vanilla." Just be sure to use different names and not to cross-reference them.

Be aware that a portfolio name that is really a self-congratulatory title ("Princess Lovely," "Pretty Baby," "Ms. Gorgeous," etc.) is a sure sign of an amateur, while overtly

29

sexy names ("WetGurl," "Lickable," and the like) will make people think you're looking for pornography gigs. Personally, I use my real name for my main portfolio and a neutral alias for my art nude portfolio, and this has worked well for me over the years.

What should you say about yourself? The first thing you should do is go look at some other modeling profiles – but be sure to have an air sickness bag handy. Sometimes I think that if I read one more beginner model's profile that says "modeling is my passion," I'll scream. Another thing to avoid is a list of demands or conditions: there are enough models competing for employment that most clients will steer clear of anyone who looks like they might be difficult to work with. Long, rambling autobiographies also put people off.

It's best to approach your profile as you would a professional cover letter. Would you use text-speak, all caps, bad grammar, or sloppy formatting in a cover letter? Would you forget to check your spelling?

Keep overly personal information out of your profile and, very importantly, be positive. An upbeat attitude will set you apart in a sea of pretty faces. Nobody wants to hire a downer, a diva, or a douchebag.

Be honest about your measurements. If you don't deliver on what you promise, you're going to have disappointed clients who will share their disappointments with others.

Don't write your profile in the third person: "Ms. Smith was crowned Miss West Chicago in 2006 . . . " Nobody is going to believe someone else wrote this about you, so it'll make you sound vaguely dishonest.

The best approach is a short, friendly, positive paragraph or two that says you are a beginner but eager to learn, what days and times you are usually available to shoot, and a brief statement about what your posing limits

are. Just give them useful information briefly stated in a positive, upbeat tone.

What about nudity? If you're under-age or uncomfortable with nudity (implied or otherwise), then by all means make your position clear in your profile. But be aware that there is a right way to do this. The female form has been admired artistically for centuries, and nearly every supermodel alive has bared it all for art. This is a perfect topic on which to practice the 'keep it positive' philosophy. Say something like: "although I appreciate the beauty of the nude form and all it has contributed to art, posing nude is not for me. Thank you for understanding." This will keep you from offending photographers and fellow models who do shoot nudes.

http://www.you.com
Eventually you're going to want to set up your own professional website. The best course of action here is to go for a simple, uncluttered, professional look, in neutral colors. Although this may sound boring, commercial clients will see it as a positive. Fine art clients will like it too, as it suggests that you're just as New York-sophisticated as they are. Cutesy/flirty themes can easily look immature, and even tasteful complexity on your website only serves to draw attention away from your pictures. Not only is a simple design more universally appealing, it'll also load quicker on clunky Internet connections.

As usual, if you're going to send commercial clients to your site, keep full nudes somewhere else or install a hidden link that only nude-loving clients will be told about (be careful here, though, not to unintentionally connect your professional name with your nude images; Google can be a double-edged sword that way). You can technically put as many images as you want on your site but quality over quantity is the guideline. A dozen images divided between two categories (like "Fashion" and "Beauty" or whatever

areas you want to specialize in) are plenty to begin with. Feel free to add a few more as you get them, but only if they are of high quality.

Include a bio, but keep it short and, if possible, intriguing. Visitors risk being bored by your whole life story; besides, you want them to leave wishing they knew more about you. A blog can also add to your credibility, but only if (a) it's only about business, (b) it's intelligent or at least well-informed, (c) it's relentlessly positive and enthusiastic (without being over the top), and (d) you update it at least once or twice a month (nothing is more deadly to a website's image than a blog that hasn't been touched in months). Leave your drama and eccentric opinions for your personal Facebook page.

Your site should include a contact form, of course, or a link to your business email. Once you get a few satisfied customers under your belt, a testimonial page is a great idea. Down the road you may also want to consider uploading a short, professional, behind-the-scenes video or two.

You can mention that you have reasonable rates, but don't list them specifically: a client might be considering offering you a rate far higher than your standard. Also, don't follow the practice of models whose websites assure potential clients that their rates are "negotiable." A statement like that suggests you don't think your own rates are reasonable; it's simply an invitation for clients to nickel-and-dime you.

Resist the temptation to market other talents on your site unless they complement your modeling. For example, mentioning that you're also a painter and a poet may give your site a "jack of all trades, master of none" vibe. You want to look like you're a model through and through.

Don't sell out to Ad-Sense or some other ad-placing company. I've come across modeling sites that are professional and impressive until you let your eye wander to the side of the screen, which is a trash-heap of garish ads for

dating sites, bogus modeling schools, laxatives, and pills for Erectile Dysfunction. What this says to potential clients is that you specialize not in modeling, but in selling out.

The best way to sell your website is to have fabulous pictures attractively presented, and to use old-fashioned networking. Mention your website in all your modeling pages, any online magazine interviews, your Facebook pages, Twitter, tumblr, your personal blog, your professional blog, and have your friends and family mention it on their blogs. Do testimonial and link-swaps with every willing body you've worked with and be sure to link to it in every professional email you send.

On the web, your persona should be professional, knowledgeable, hardworking, in control, and in demand, but at the same time approachable. Any eccentricities or controversial opinions you may have should be excluded (unless they are relevant to your work) because such material can alienate clients. If you're an NRA member who voted for John McCain, the left-wing vegan fashion designer may feel uncomfortable hiring you. Making your website uncontroversial without making it bland is a bit of a balancing act, but worth the trouble.

Other Websites

Facebook. In addition to being another venue where you can put up pictures, Facebook's sheer ubiquity means that you can connect with pretty much anybody as part of your networking strategy. Once you start getting regular work, you should also make a professional Facebook page; you may not feel like a celebrity, but marketing isn't about how you feel – it's about how other people see you. This will also further increase your Google association with modeling, lead to wider visibility, and offer a non-intrusive way to stay in touch with important people. I recently booked a major fashion gig because I kept in casual Facebook contact with a

photographer I had worked with; when it came time for him to shoot something with stylists for Vogue, he thought of me.

Social sites are also a good way to let people know where you are and what you're doing. It's easy to broadcast the name of the photographer or client you're shooting with, the location of the shoot, what time it's scheduled to start and end, and where you're going afterward. This helps nervous newbie models (and their families) feel safer.

Subscription sites. A bunch of websites have also sprung up for people who are willing to pay to gawk at nude females. Zivity, GodsGirls, Suicide Girls, and similar sites are the modern incarnations of Playboy, Penthouse, and Hustler. They range from relatively tasteful to cheesy and even completely pornographic. I personally have not participated in such websites, but some well-known models and photographers seem happy to use them and evidently make money from them. If this sounds like something you're interested in, though, you should do your research thoroughly before diving in.

Others. There are also sites that are partway between Facebook and the subscription cheesecake sites, including sites like tumblr, and DeviantArt. On these sites, you can put up any kind of pictures you like, nude or clothed, you can blog, and you can talk to your fans/admirers. You don't get paid, but as with Facebook, your potential audience is huge. On all of these sites, send appreciative acknowledgements to your respectful fans when possible, and freely ignore the rude/creepy ones.

Surely all your ports, Facebook, Twitter, tumblr, and your own website should be all you need, right? Technically, yes, but why stop there? Don't forget the online "magazines" that are popping up all over the place. Some of these are vanity projects with audiences of one, but others are legitimate commercial or artistic venues. Either way,

hitting as many of them as possible can't hurt and could help. Once you have some good images and a bit of a resume, giving interviews to as many of these publications as you can is always good business.

Chapter 6

What You Need to Book Work Offline

As a self-represented model, it's entirely up to you to get all of your marketing materials in order. This includes a book clients can flip through, as well as comps and business cards you can leave with them. Putting these items together may seem a little overwhelming, but it is actually pretty simple.

Freelance models generally conduct their business over the Internet, and you can go far making contacts strictly online. Many castings for such models don't require face-to-face meetings, and you may be able to land the job based exclusively on your online persona, portfolio, and professional demeanor.

When you do meet industry people in person, though, you should come across as smart, confident, cooperative, and professional. This is where a trifecta of great personality, a professional book, and fantastic comp cards will come into play.

Your Book

This physical portfolio of photos showcases the model's tearsheets (pages "torn" from magazines) and her best work. Agencies uniformly require their models to have books, and not having one may suggest to some potential clients that you're not serious about your occupation. For this reason, even a strictly freelance model should at least

have a handful of photos printed out and presented in book form. (iPads are great for showing work as well, if you have $500+ to spare.)

Basics

The key concept in putting together a book is "quality over quantity." Only your very best work should appear here, and, if they aren't actual magazine tearsheets, the prints should be of the best quality. A book should have between six and 14 excellent photographs of you. Most agencies use 9 x12 portfolios, so this size will likely seem the most professional to potential clients. As far as content goes, the more tearsheets, the better (as long as they're flattering).

A fashion model's book should have a good mix of headshots, fashion shots, and at least one or two shots that give a good idea of your body shape. If you're strictly trying to appeal to the glamour market, increase the number of lingerie/swimwear and flirty face shots. A model specializing in any genre can add classy implied nudes (i.e., photographs where some private part of the body is obviously unclothed, but not visible), but I would recommend keeping a separate book for any full nude work.

Agency books have covers with the agency name printed on a solid color. To appear professional without an agency-branded book I recommend sticking with black covers (no patterns, cutesy decals or artwork), leather if you can afford it, but no biggie if you can't. Avoid ring binders or pocket folders, and make sure the plastic protector sleeves you use don't have office brands typed on the edges. There are Internet retailers that sell books specifically designed for models, if you can afford to splurge a bit.

You really only need one copy of your book, but having a backup is a good idea in case you leave it in a cab or your dog pees on it. Keeping high-resolution versions of the photographs (scanning tearsheets if necessary) on a hard

drive or CD is also a good backup idea. If you can't get the files, at least keep the photographers' contact info somewhere you won't lose it. Photographers guard their image files like parts of their own bodies, so if you have access to a photographer who took a picture of you, you'll likely have access to the picture.

At networking events you can just ask people if they'd like to flip through your book; at castings, auditions, or open calls, wait until asked. Depending on how the particular casting is set up, the casting director may sit down with you and go through your book; other times you may drop it off with someone while another takes you to have some Polaroids snapped or to read a line of copy; just don't forget to pick it up on your way out.

Questions you should be prepared to answer about your book include:

- Where was this or that photo taken?
- What were they taken for?
- How long ago were they taken?

Make sure you know the answers to these questions, in addition to more general questions about your experience level, what you like best about modeling, what you like least, and so on. The people conducting these interviews are usually friendly, but you should be prepared for the occasional jerkoff who remarks "you don't quite have the body for that swimsuit do you?" or "it's amazing how stocky you look in this photo." Just smile sweetly, and fantasize about catching him in a dark alley sometime.

Photographs for Your Book

A handful of clean snapshots may be enough to get you going on the networking sites, but odds are they won't be of sufficient quality to use in your book. So once you've

begun attracting skilled photographers, you should make your shoots with them an opportunity for book-building.

When you begin this process, keep in mind that you'll want to focus on what your book needs:

- A relatively even mixture of your best beauty and body shots (you should be wearing heels in some of the body shots, as it adds tone to your legs and butt)
- Images showing at least 3 different facial expressions
- Images showing at least 5 different poses

This variety will convince clients that you're versatile and require little direction on set.

It isn't necessary to hire an expensive professional to shoot for your book as long as you choose your photographer carefully. Search the modeling sites for photographers in your area. Once you think you've found a winner, evaluate his work not only for artistic merit, but for how it makes his models look. His images may be outstanding pieces of art, yet may not be flattering to his models. Better to shoot with a slightly less skilled photographer who makes you look good than a brilliant artist who makes you look unappealing.

It's also a good idea to be cautious when doing trade (that is, modeling for a photographer in exchange for some of the pictures from the shoot), even with professional photographers. A normally fantastic shooter may (perhaps subconsciously) slack off when not being paid.

To avoid a lot of hassle, sometimes it's worth it to just pay a photographer to shoot for your book. If you decide to take this route, find the best photographer in your area, and ask the following questions:

- What can he offer for what you can afford to pay?
- Will he provide a makeup artist?
- Will there be a hairstylist?

- Will wardrobe be provided and, if not, does he have any specific requests for what you should bring?
- How many looks will he shoot for you?
- Will he provide retouching?
- Is he willing to give you high-resolution image files? (Low resolution files won't print out as decent 9"x12"s.)
- Is he willing to sign a release granting you permission to print copies for your book and display them on your website and modeling ports?

Before you commit to the shoot, talk to the photographer once or twice over the phone to get a feel for his personality, and to make sure you'll be comfortable shooting with him. If you're at all irritated or creeped out, do both of you a favor and move on to the next photographer on your list (this goes for trade shoots as well).

Finally, once you're ready to shoot, write down exactly what you and the photographer have agreed on, and make sure both of you sign it before money changes hands. While this can seem like a hassle or an expression of distrust, it can prevent misunderstandings – and sometimes intense migraines – down the road. I would go so far as to say that it's not worth working with a photographer who's not willing to sign a simple agreement of this type.

Every market has at least a few photographers who are exceptionally good for bookwork. When I want to update my book, I turn to one of the very best: Todd (aka TH) Taylor, a photographer who can fool everyone into thinking you're a supermodel with just one picture. He's one of the rare artists who can shoot fashion in an edgy, conceptual way and have it come out tasteful, beautiful, and exhilarating all at once. On top of his amazing photographic talent, Todd personally does makeup, wardrobe, concepts, set design, and retouching, all spectacularly well. He's more

than worth his rates and I always have a great time working with him. Any photographer you consider hiring should have similar qualities.

Once you decide to invest in the best photographer you can, you'll want to take full advantage of the opportunity, including bringing the right wardrobe to the shoot. As always, come with any specific items the photographer requests. He may have studied your look and decided what would suit you best, or he may have a fondness currently for a particular type of wardrobe. But since this is also a shoot for your book, make sure to bring four or so outfits that fit into the modeling genre you're trying to break into. Don't forget matching shoes and accessories. I can't stress the importance of accessories enough!

You may also want to bring a couple of outfits in a style exactly the opposite of most of your shoot wardrobe, just to showcase your versatility. Also, it can be good to make part of your shoot a semi-controlled free-for-all, even if only for a few minutes. Mix and match things that wouldn't normally go together. Wear garments as hats, necklaces around your thigh, etc. Get creative! Most of these shots won't work, but the ones that do will be unlike anyone else's. If in doubt, run your ideas past your photographer; after all, he has a lot more experience at this point than you do.

Try to show all sides of your personality. The free-for-all part is usually good for smiles and laughs; also do some shots with a more calm and reflective feel. The more emotion you can stir up in viewers, the more they'll be able to relate to you. That is exactly what you want your book to do.

But most importantly, have a good time. Building your book should be fun. If it begins to feel too much like work, odds are the photos won't turn out as well as they should. Shots of a model who's enjoying herself are usually

worlds above shots where she is rattled, distracted, or annoyed.

Finally, try not to hound the photographer for your pictures too soon after the shoot. It's best to wait at least a few weeks. Asking sooner may show your inexperience with the process, and irritate the photographer. He may also rush through the retouching, which defeats the purpose of you spending all that money on him. If over a month goes by without any images, you have every right to send him a reminder. However, this is rarely a problem on a paid shoot.

Comp Cards and Business Cards

While a freelance model should certainly try to put together a book as soon as she has the shots to do it, comp cards, or at the very least business cards, come one slight step before your book in both time and importance, for the simple reason that the client can keep them. In addition, industry people assume that a professional model will have comp cards (unless she books exclusively through the Internet). If you're planning to attend castings/auditions and networking events, you'll likely be asked for your comp cards.

Comp cards are typically 8.5 x 5.5 inches in size, and professionally printed on good card stock. They usually feature one beauty shot and your name on the front, and on the back anywhere from two to six photos, with at least one full length (as usual, no nudes on anything you are expecting commercial clients to see). Your measurements are also listed on the back along with your height, weight, dress size, shoe size, hair and eye color, as well as your contact info and online links. You may also choose to list the genres you specialize in. You should stick with black or white text in a conservative font, and white, black, or gray for the background and borders; anything else risks looking unprofessional. Hand these out liberally at castings, auditions, go-sees, open-calls, and networking events.

You generally only need one comp card design for all your work, unless you're also shooting in some specialized genre like nudes or fitness. As far as body part modeling, if you have a killer set of hands just make one of the photos on the back of your card a close-up of them, or a beauty shot with your hands around your face. I've gotten several hand gigs this way. (However, if you intend to work primarily as a parts model, invest in a separate comp card for that sole purpose.)

Beware of typecasting yourself: your comp card should show your versatility. If you're the fresh-faced girl next door in all your shots, casting directors are going to have a hard time picturing you in the sexy perfume ad or the line of biker jackets. Be natural in a shot or two, include a photo with a more done-up look, and perhaps one with a sexier attitude. Also, be honest about your height, measurements and anything else on your cards, as there's a chance that you'll be measured at a casting – and aside from the awkwardness of getting caught in a lie, the client may take your deception as a warning sign of even greater outrages to come, and refuse to hire you.

Finally, never underestimate the business card. Even if you have a book and comp cards, business cards come in handy because you always have a marketing tool in your purse or wallet. These cards should have your picture on them, as well as your contact information and website or portfolio link. You never know when you're going to run into someone who can use your services.

I was once asked by a fellow shopper at Toys R Us if I ever modeled. His sister had a bridal show at a wedding expo the next day, and they were short a girl. I pressed my business card into his hand (I don't usually take my book or comps to Toys R Us), which he then passed on to his sister. I got the job and made a quick $500. This was not an isolated incident: I've gotten a surprising number of jobs this way, including a hair salon advertisement, a stock shoot at an

outdoor café, a swimwear campaign, and a gig posing for a fine art class. Usually this only happens when I'm at least wearing a pair of heels, some foundation, mascara, and lipstick, but the moral of the story is that even if you decide to leave the house without a cocktail dress on, at least don't leave it without your business cards and a positive, friendly attitude.

Chapter 7

Finding and Vetting Work; Rates and Negotiation

The time, expense, and labor you put into setting up your career will all be in vain if you can't successfully find clients and negotiate with them.

Initial Correspondence

Once you've set up your web presence, you should browse the modeling, artistic, and social sites, as well as the online magazines, and make a list of photographers whose work you admire and who are within a reasonable distance of where you live. Many of them will have portfolios on one or more of the modeling sites you belong to. To each of these you should send a friendly email through the site's private messaging system, something like:

"Dear Mr. Jones: I am a new model in the area, and have been admiring your work. I especially like your photographs of the tattooed lady with the ducks perching on her shoulders [or whatever]. I think I might be of use to you in some of your projects. While I'm just starting out and don't have a lot of experience, I'm very enthusiastic and willing to learn. You can see my portfolio at _(weblink)____. I'm available ___(state days and times)____. Please let me know if you would like to work with me."

You can also browse through the casting call sections of these networking sites to see if anybody is in need of a model. In any event, remember your level of experience when you're contacting and negotiating with prospective clients. Don't expect anyone to pay you at first. You should be open to a fair amount of trade work until you get a good portfolio and reputation. In fact, if the photographer is good enough, you may even consider offering to pay him if he turns down an offer of trade, on the same principle I mentioned when talking about building your book. A few professional pictures are worth their weight in gold to a beginner.

You can also contact more established models on the these sites with a professional, friendly, and respectful letter asking for references to photographers or clients who might want to shoot with you. But don't expect them to throw you their best clients, and don't be disappointed if they don't get back to you. This is a competitive business, and sharing good clients is the exception rather than the rule. Also, some of these models may be very busy, and may put responding to questions from other models at the bottom of their priority lists. Whoever you contact, be reasonable, friendly, and appreciative.

Answering your email is a vital part of booking work. This seems obvious, but an amazing number of beginning models go through the trouble of setting up portfolios and then fail to promptly answer work inquiries. These girls soon find themselves written off and ignored; nobody wants to waste time on amateurs. I sometimes get dozens of PMs a day, but it's very rare that I don't get back to everyone within 48 hours if they're at all hinting that they want to book me.

* * *

If you have any modeling potential at all and you follow the steps outlined above persistently and conscientiously, you will start getting work offers. That's when things start to get interesting.

Vetting

The first, invariable rule in freelance modeling is: never take a job you haven't vetted thoroughly. From raw beginner to hardened veteran, no model should ever shoot with a new client or photographer without checking them out thoroughly first. I take jobs based on the following factors:

- The client's credibility
- What his references say
- The compensation offered
- The weight the work could give my resume or portfolio
- Where the work takes me both physically and career-wise

I'll travel anywhere safe for my job, but not before I've communicated with at least two or three of the client's former models, combed through the modeling site forums for any discussion of him, and consulted Google and Facebook to get any other information I can dig up. If others are going to be on set (makeup artist, wardrobe stylist, photographer's assistant, etc.), I check them out almost as thoroughly. While nothing is foolproof, I've been getting work through the Internet for nearly 8 years now, have traveled all over the globe alone, and have yet to encounter a serious danger at a shoot (at least not one booked during my freelance years; some agency bookers are less cautious than I am).

As part of this vetting process, get an idea of what the photographer/art director is planning for the shoot. If someone is reluctant or evasive in discussing this, it's a sign that you may want to pass the job up. If I ask a client for the basic data that would be on a call sheet for a commercial job (time and date, duration, pay, theme, any items I'm expected to bring, whether or not there will be hair/makeup provided) and they send me back only a couple of potential dates, I will very politely ask again. If their next response still doesn't cover my questions in full, my BS-meter starts registering; the client is showing signs of unprofessionalism and flighty-brain syndrome, not to mention disrespect for my time.

Assuming you get a description of the client's concept, you need to decide if you're comfortable doing it. You've made your posing limits clear in your online portfolio; unless what the photographer wants to do exceeds these limits, the strong presumption should be in favor of taking any safe work that comes along. However, you can't think of everything in advance, and a photographer may propose a concept you haven't thought about, but which you are unwilling to do. In that case, don't take the job (and update your posing limits online).

You would also be well advised to avoid clients/photographers whose correspondence or online profiles take a moralistic or scolding tone ("I will not tolerate a model who shows up 25 minutes late, you'd better have your legs and underarms freshly shaven" etc.). The technical term for this type of client is "jerkoff." These guys think they know it all, and that models are brainless. The things they preach are mostly common sense, but the scolding, disapproving tone gives you a preview of what you're likely to experience with them on set. Life is too short.

I also try to avoid photographers who are eager to let you know how many internationally acclaimed magazines they've shot for, or that they discovered such and such A-list

celebrity, especially if the quality of their photos doesn't match their rhetoric. Folks that claim that they can make you famous or ask you for large amounts of money need to be written off, and anyone who gives you the "Do you know who I am?" attitude is usually not worth the aggravation, even if you do know who they are.

Don't Get Used

Some years ago, I went to an after-party in the penthouse of a Miami hotel, and was treated to a surreal spectacle. About a dozen models and a dozen crew members had shot nearly 12 straight hours, and were now relaxing and mingling as the alcohol flowed. The sexual tension in the room was so thick you could have cut it with a knife. It wasn't long before the producer – an unattractive man well-stricken in years – found himself in the arms of a 19-year-old model, while several other members of the crew were also being groped by barely legal ladies. Of course, the men didn't seem to mind too much.

Unfortunately, this kind of thing goes on a lot. There are jerks who will promise wide-eyed aspiring models fame and fortune in exchange for sex. In other cases, the girls simply offer themselves, incorrectly believing that this is how business is done in the industry.

A "trade" like this may sound like a mutually beneficial arrangement, but usually the benefits are not at all mutual. More often than not, the model will follow through with her side of the bargain, but never gets her promised reward. In a way, this is what she deserves for trying to take a shortcut to the top; however, the male side of the sketch comes out looking even worse, in my opinion. Using a position of perceived power to take advantage of naive young girls doesn't exactly put you in the "gentleman" category.

I was once in talks to shoot with a celebrity photographer for his latest book, and he invited me to

Hollywood for a meeting. He was already drunk when I arrived, and opened the negotiations by trying to grab my ass. Even after I forcefully rejected this proposal, the distinguished artist just couldn't talk business for more than a few seconds at a time. He mentioned work only to name-drop who he'd shot and where he'd been published, no doubt to convince me that the honor of being photographed by him was well worth having sex with an obnoxious SOB. I had the almost uncontrollable urge to throw his whiskey glass at his face; instead I managed a polite refusal and a graceful exit. Truthfully, I would be embarrassed to be in any of his books lest people think I had achieved the honor by horizontal means.

In fact, by refusing such unprofessional offers – politely if possible, but rudely if necessary – you may actually have a better chance of getting the work you're being offered. Consider the psychology: if you sleep with someone like this, to him you're no longer a professional applying for a job on the basis of your qualifications, but instead someone who is trying to get the job regardless of qualifications. Even if he's the one who proposed the trade, he'll now wonder why you didn't have the confidence to try to land the gig legitimately. He may start second-guessing his own judgment that you have what it takes to do the work. While you now expect him to hold up his side of the bargain, he'll likely be reluctant to compromise his professional relationships by hiring a potentially unqualified model.

On the other hand, if you turn down his proposition, he'll probably have more respect for you, and will be able to hire you with a clear conscience (if you're qualified). But win or lose, you'll at least have the satisfaction of knowing that your professional integrity is intact.

Negotiating

As a beginning model, you shouldn't ask for anything monetary until you've proven yourself at least a little. However, if the client/photographer initiates talk about money, feel free to negotiate – just don't get outrageous.

For example, if you're offered $250 for a full day, you might agree to the $250 with the stipulation that they kick in a travel allowance to cover gas and parking, or tell them that your minimum daily rate is $300. For the sake of your reputation, don't try to negotiate top rates when you're very clearly still inexperienced. Also, be aware that even the most successful and sought-after freelance models currently aren't asking for more than $75-125/hour for non-commercial gigs.

In general, only quote your rates to photographers and clients when they don't make you an offer first. Many times by waiting for the client to set the compensation, I have been offered several hundred dollars more than I would have initially asked for.

Once you have a decent book of work, you may begin charging modest prices, but some trial and error is often needed in doing this. If you notice a serious drop-off in inquiries after setting your prices, lower them back to a point where the work starts rolling in again, and wait awhile before trying again to increase them.

Promotions

Offering discounts is a great way to make a client feel appreciated. For example, an experienced model may normally charge $100/hr + travel with a 2-hour minimum, but if a photographer/client books her for a half day (4 hours), she might lower the cost to $350 + travel, or $650 + travel for a full day (8 hours). If someone is interested in hiring you for a second gig, it may be good client relations to offer a rebooking discount to sweeten the pot and close the deal.

Think of it this way: you'll make more money in the long run if you charge a fair rate, because you're more likely

to get a consistent stream of bookings. When you ask for too much, you may still get some bookings but you likely won't be able to keep your work schedule full.

Standard rates are good, but in the end be flexible. Take into account the client's individual situation, as well as what they can offer outside of compensation: for example, will working with them increase your visibility and prestige, or open doors to other promising gigs or repeat bookings?

Run a sale if you find that you're getting insufficient work. For example, lower your half- and full-day rates by 20%. If after 2 weeks this is still not encouraging enough work, lower them again with the Act Now tag line "One more week only!" to 40% off. You could also try "buy 3 hours, get one free."

You can also try offering a two-for-one deal in the form of either you and another model or you and a makeup artist for the price of one model. I've also offered a two-for-one deal allowing two photographers to split my full day rate and shoot with me simultaneously all day. You can get as creative as you want, but remember to keep it simple; you don't want to put off clients by confusing them.

Notice that by marketing your rate reductions as a sale, you're making it easier to raise your rates back up in the near future. This "sale" approach is better than raising and lowering your prices without explanation, which gives the impression that you thought you were worth X, but then realized you actually weren't. People will have a hard time going back to your higher rate after such a move. It boils down to the clients believing they're getting a deal vs. feeling like you're trying to put one over on them.

The Promotional Mailer
The most often overlooked method of self-promotion is the use of the good old postal system. With less mail then ever finding it's way directly into the hands of potential

clients, the physical mail they do get receives a bit more attention then it used to.

One model I know sends out large padded envelopes to her potential clients. Inside she includes a comp card, a formal resume, a business card and a letter explaining why she would be a good fit for any of their upcoming projects. Sending this much material to a hundred addresses is a big expense and a lot of work. However, I can see why she does it: this method has netted her over $10,000 in bookings.

I never get that elaborate with my promotional mailers, yet they still land me a significant amount of work. My course of action is much more affordable and easy. I call it "'the postcard.'"

I use 5.5x8.5 postcards that feature the images from the back of my current comp card. Instead of my measurements, the card shows my name, work specialties, and website address. Here is an example:

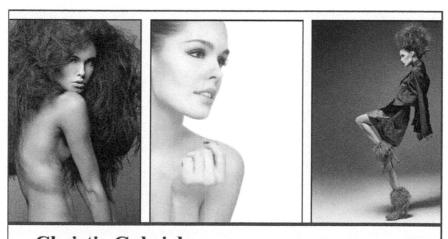

Christie Gabriel
Fashion, Art, Beauty and Hand Model
christiegabriel.com

On the back of the card I handwrite a short, friendly note saying that I'd like to be considered for future projects.

The whole idea of sending this card is to give the client a gentle nudge in favor of hiring you. Don't try to turn it into a hard sell, as that will destroy the more personal feel a postcard should provide.

In order to make use of this method, you're going to need a list of potential clients. I'll tell you right now that I have never heard of anyone having much success with purchased lists, so don't waste your money. Instead, make your own list.

Use Google to find relevant clientele in your area. You'll need their mailing addresses as well as the name of whoever makes the decisions. If you can't find that person's name, just call the company and ask them.

Chapter 8

How to be a Proper Poser

By now you should realize that the actual time freelance models spend shooting is dwarfed by the amount of time spent on all the less fun business logistics. The reward for all this work, however, is the exhilarating hours that you do get to spend performing on set as a model. In this chapter I start to focus on the craft of modeling, and how to excel at it.

Being A Poser

After all the work you've done to get your career going, it all comes down to this: Are you good at posing for the camera? Paradoxically, the resources for learning this all-important skill are few; even the top agencies don't teach their models how to pose. Some "modeling schools" pretend to, but their "courses" are mostly useless.

Furthermore, posing is very personal and model-specific: every body type and face has particular poses and expressions that are flattering and others that are not. Some established models and photographers conduct one-on-one seminars with aspiring models to give them feedback on what poses/colors/expressions/clothes work for them, and what their "good side" and "good points" are. Paying for such help may be a worthwhile business expense for many beginners.

Another problem with poses is that about half a dozen of them come naturally, and so are vastly overworked. Part of skilled posing is to avoid falling back every couple of minutes into the same clichéd stances.

Yet another difficulty is that you not only have to know how to pose, but your poses and facial expressions have to flow – that is, transform smoothly and naturally into each other. This is partly to give the photographer value for his money by giving him plenty to shoot, but it's also because static poses look – well, static. The human body doesn't naturally freeze in position: if you watch people going about their daily business, you'll notice that they're always moving. Even standing in line they shift from foot to foot, cross their arms, look around, raise their eyebrows, purse their lips, adjust their clothes.

There's a tendency among newbies to freeze for the camera when being photographed. This just makes you look robotic. The job of the camera and lights is to freeze you; your job is to look good. A pose that is just a momentary pause in a continuous flow of poses looks natural and graceful because the body is doing what it does naturally: moving.

You don't have to worry that you only pause for a couple of seconds in each pose: a good photographer will be watching you closely, and as you get into a pose he likes the lights will flash and you'll know it's time to flow into the next. Sometimes you have to pause a little longer while the photographer refocuses or does whatever photographers do while they're cursing under their breath and fumbling with their cameras. Through it all, you should always have the feeling in your body of a smoothly flowing motion with a momentary pause, not separate frozen positions. Sometimes the photographer will want you to freeze a pose, but if he does, he'll let you know.

Learning Poses and Expressions

But before your poses can flow naturally into each other, you'll need to know some poses. The first thing any beginning model should do is find at least twenty-one poses that flatter her individual body. You shouldn't go to a shoot until you know a minimum of seven standing, seven sitting, and seven reclining poses. Experienced models have a much larger arsenal of poses, and make up more on the fly, but for now just focus on getting a handful down for each position. The more appropriate poses you can flow through in a row without instruction from the photographer, the more experienced you'll look.

The photographs included later in this chapter show me posing for various shoots, and are included to give you an idea of the poses that work for different types of shoots. Some of these poses may work for you; others may not. A wonderful source of posing ideas is to look through the portfolios of accomplished models on your favorite modeling site. Be sure to study each pose in the mirror and evaluate how it suits your particular face and body. Also keep in mind the geometry, lines, and mood each pose creates, and how it will work when the light in the shot is coming from different angles.

Once you have several poses logged into your memory, you'll want to start working on facial expressions. You should have no fewer than seven of these too, to start. If you're having trouble here, write a list of all the emotions you can think of, and then try to silently express them in a mirror. Not all of them will look attractive, but that's not what you're concerned with at this point. All that's important at first is that they look believable.

Once you've gone through this exercise a few times, circle the emotions on your list that do look believable (hopefully there are at least seven). The next step is to make sure that the happy emotions you circled make you look good. You should light up a bit when you make these

expressions. If you don't see that fleeting light in your eyes, the expression is probably coming across as stiff or fake-looking. One technique used by Method actors is helpful here: every time you want to appear happy, in love, proud, nostalgic, etc., think of a time when you really felt like that in the past, and let the feeling flow into you from your memory; then just let yourself show it naturally.

Next, work on face angles and hand placement. Come up with at least seven different ways to place your hands around your face. After you have some good hand positions, work your head a bit. For a good profile shot, don't turn more than 90 degrees from the camera. Also, watch out for chin-down poses. These can cause studio lights to create dark circles under your eyes; besides, you'll look like you have no neck. Finally, bad head positioning can make even a thin model look like she has a double chin. To avoid this, keep your chin stuck out a bit further than feels natural; this is especially important if you are being instructed to look down.

Other than this general advice, good head positioning depends a lot on the specific lighting you're working with, so this is where the photographer will have to give you a lot of direction, mumbling out a steady stream of "head to the left, chin up, tilt a tiny bit to the right, face me, head straighter, head to the left" etc. Don't take it personally, and follow the instructions; usually he's just trying to see what position works best with the lighting. Every model I've ever worked with (beginners and veterans alike) need almost the same amount of direction when it comes to head positioning. Those lighting sets can be pretty complex, but fortunately nobody expects you to have more than a basic understanding of that aspect of things.

Now that you have your basic poses, expressions, and hand placements figured out, it's time to start putting them together. This is where you really wear out your mirror.

Strike a pose while flashing an expression you've mastered; then (without changing the pose), choose another expression, then another. After you've gone through several expressions, switch to a new pose and go through all your expressions again. Keep going until you've been through all of your 21 plus poses and coupled each one with all 7 plus expressions.

Now practice flowing one pose/expression combination into another. After you can do that, try three. Analyze the shapes and angles your poses make, and at what angle to the mirror (eventually the camera) you have to position a certain pose for it to look most flattering. Practice until you can keep flowing for 15 minutes without stopping (perhaps re-using some pose/expression combinations). Many experienced models have links in their ports to "behind-the-scenes" videos that show them posing. Watch as many of these as you can find.

Given the national obsession with thinness, learning poses that make you look taller and/or skinnier is worthwhile. (An experienced photographer will know tricks with angles, depth, etc., that can help you out in this area. Just don't be surprised if he lies down on the ground and has you stand really close to him – this seems odd at first, but it works wonders.)

Good posture makes you look taller, so be sure to stand up long and straight. No matter what kind of pose you're in, you should always be able to feel at least a slight stretch somewhere on your body.

To slim your stomach, instead of just sucking in (which is hard to do without looking like you're doing it), try stiffening your stomach muscles and imagine you are pulling the sides of your abs together. This will make your belly appear more toned and flat without the crease you get from sucking in. You also don't have to hold your breath using this approach.

Finally, keeping your lower half in profile to the lens while rotating your upper body a quarter of the way back toward the camera will also make you look slimmer. It feels awkward, but when you see the results, you'll resolve to get used to it.

Be A Stereotype – For Awhile

There are certain types of poses and expressions that photographers will expect you to know are associated with particular modeling genres. While it's always possible to break these stereotypes, you should generally let the photographer take the lead here. For example, if you're modeling lingerie, you should use classic glamour poses until instructed otherwise. If the photographer is shooting close-ups of your face, beauty poses (i.e. hands around face/neck area) are the order of the day, again until he tells you to knock it off. Starting off with poses that are at odds with the type of shoot being conducted not only brands you as an amateur, but is likely to irritate the client.

If in doubt, play it safe and go with the stereotype; then once you've established that you know the rules, the photographer/client may be pleased if you push the envelope a bit with some outside-the-norm poses. Try one or two, and if they're a hit you may try a few more, but if they draw boos, go back to the traditional poses for that type of shoot.

The standard posing expectations for each type of shoot are listed below.

Beauty shoots (i.e., close-ups of your face): Hands around the face/neck (make sure your nails are in tip-top shape). Vibrant emotions. The focus is usually on the eyes, so be sure to let yourself actually feel the emotions you are portraying; this will help them come across in your eyes. Also, make sure your hand placements are not throwing your eyes into shadow. The following five pages show examples of beauty poses:

Use your hands often when posing for beauty shots.
Photo © Duke Morse 2011

Play coy with a mischievous smile. Photo © Duke Morse 2011

Look up and out to make your eyes appear larger.
Photo © TH Taylor 2011

Remember to use your profile! Photo © Duke Morse 2011

Don't be afraid to get ridiculous on occasion!
Photo © Duke Morse 2011

Fashion shoots: All about attitude/high impact, unusual and/or awkward poses, serious, intense emotions (anger, arrogance, regality) or the other extreme of completely blank expressions (mysteriousness); the objective here is to make the image jump off the page at the consumer. Of course, this kind of shoot is usually centered on the model's clothes, so an awareness of how your posing affects the clothes you're wearing is a must. Think about the angles and shapes your body is making so as to show the garments to their best advantage. The following six pages show examples of fashion poses:

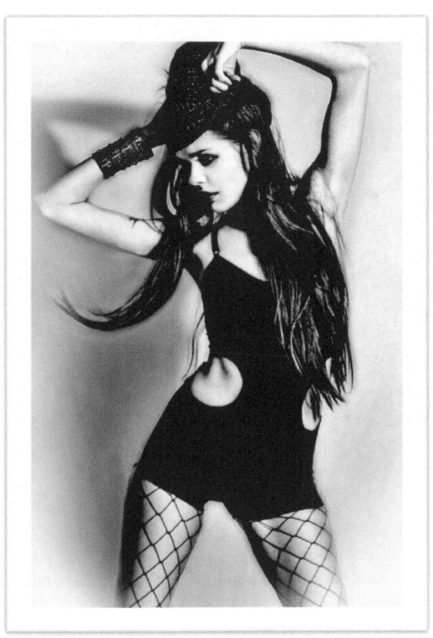

Incorporate geometry into fashion poses.
Photo © Moda Americana 2010

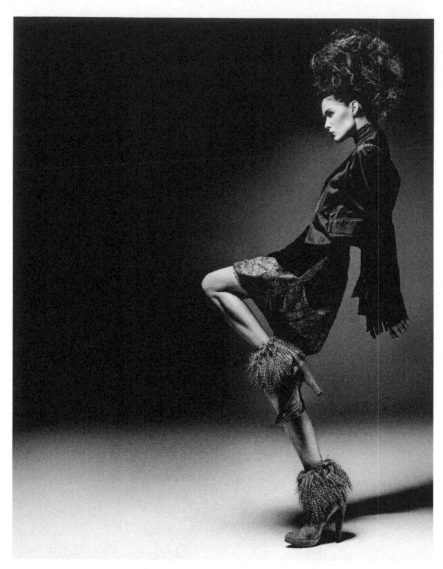

Try to create a lot of interesting lines. Photo © TH Taylor 2010

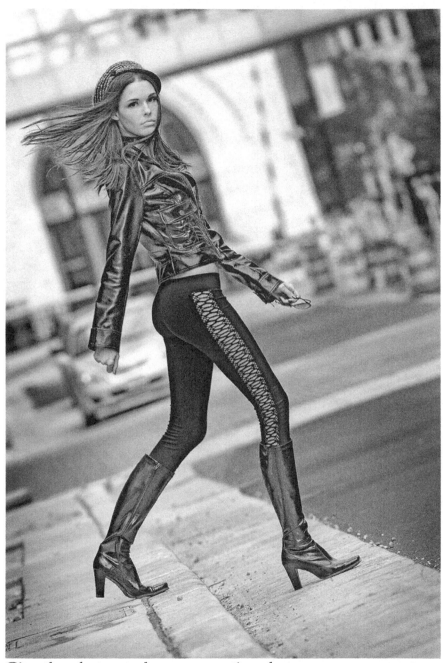

Give the photographer some action shots. Photo © TH Taylor 2009

Couple great angles with attitude. Photo © Vincent Michael 2011

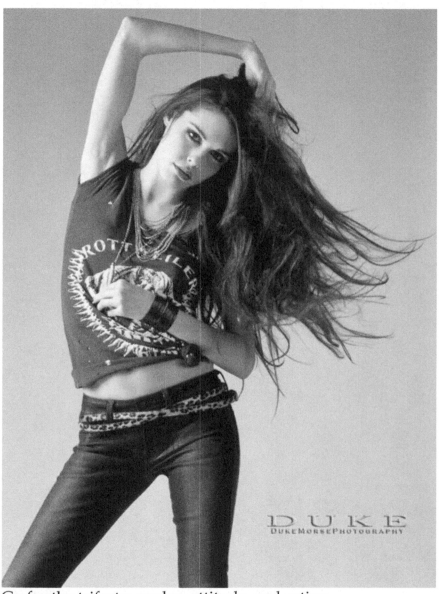

Go for the trifecta: angles, attitude, and action.
Photo © Duke Morse 2011

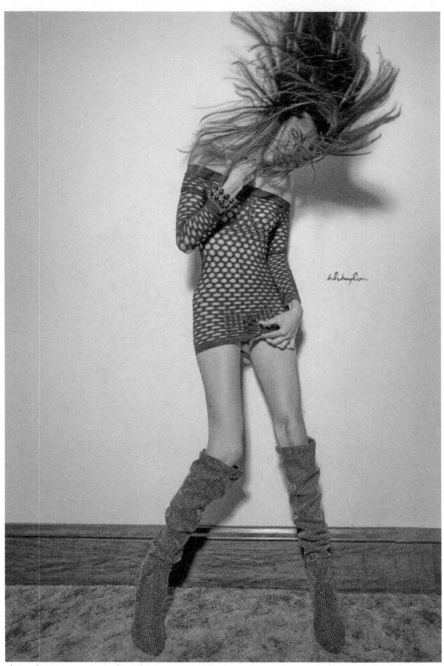

Again, get moving! Photo © TH Taylor 2011

Commercial shoots: Everyday emotions; the particular ones you need to project are based on the content of the particular shoot. (These gigs are for everything from medical insurance commercials to showing clothes in casual-wear catalogs.) You need to be able to believably portray people in real life roles. The most common emotions required are: contentment, being in love, ecstatic, focused, professional, friendly, and overwhelmed. For examples of such poses, look at advertisements for everyday items.

Glamour/lingerie shoots: Enticing, flirty, kitschy, sexy, often overdone poses that accentuate the T&A, together with seductive smiles or over-the-top pouts; on the steamier side, erotic poses and expressions. The following are examples of glamour poses:

Try a prowling sex kitten pose on for size.
Photo © Red Sky Photography 2011

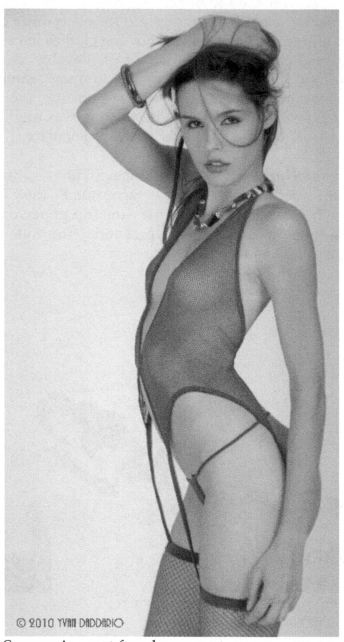

The S-curve is great for glamour. Photo © Yvan Daddario 2010

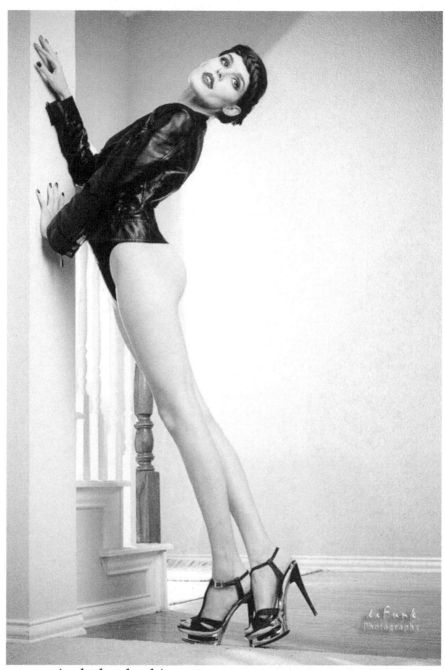

Arch that back! Photo © daFunk Photography 2011

Cross your legs to create a nice hip curve.
Photo © Brock Lawson 2011

Get those hands up in your hair! Photo © Yvan Daddario 2011

Nudes: For glamour nudes, follow the guidelines I just mentioned for glamour/lingerie shoots. For art nudes, go for more of an impersonal feel – contemplation, serenity, nonchalance/emotionlessness, strength, or innocence – or sometimes over-the-top, clearly artificial emotion, not often a middle ground. It's safe to get as ridiculous as you want once in awhile during an art shoot, using contorted, pretzel-like poses, or poses contrived to look as ugly or awkward as possible. Be aware also that some art nude photographers get annoyed if the model uses too many sexy/glamour poses during an art shoot.

It's a good idea to research the photographer's general likes and dislikes before a shoot. Look at the shots in his online ports, which he has undoubtedly chosen because he thinks they are his best; you'll likely see a pattern in the types of poses and expressions he favors. You should also try to get an idea of the concept the photographer will be going for in your particular shoot (preferably in the pre-shoot communications) so that you'll have time to practice poses or expressions that will fit. If that isn't possible, at least try to discuss it with him on set before the lights start flashing.

Asking flatly "so what do you want me to do?" may suggest to experienced photographers that you don't know your job, and may rattle inexperienced photographers who are relying on you to take the lead. It's usually better to take in as much information as you can and then use some leading questions or statements, like: "I see the wardrobe is very elegant; are you hoping to carry that vibe into the feel of the poses as well? Are you looking for more sophisticated and regal poses, or a bit of irony by adding an element of funkiness to them?" You can also ask "do you prefer to direct your models closely or is it best for you if the model poses more freely?" Make sure you listen carefully to the

photographer's answers to these questions, and then do your best to reflect his ideas and preferences in your posing.

Posing Mistakes

The best models in the world make posing "mistakes," which is one of the reasons that even highly experienced photographer/model teams often schedule a full day to get the shot they're looking for, on the assumption that many of the shots they take won't work. On the other hand, certain kinds of mistakes can brand you as an amateur, and are particularly annoying to photographers and clients.

One of the biggest posing mistakes new (and even some experienced) models make is not paying attention to the lighting while they're posing. Photographers get irritated if the model keeps making unnecessary shadows on her face by blocking the light with her arm or hand. Unless you're specifically asked to do that (or unless it's obvious you're doing it on purpose to create interesting shadows) this will just scream "amateur!"

Not pointing your toes is another mistake. Especially in sexy shots, the toes should be pointed whenever possible, even if you're wearing heels. Pointed toes lengthen the leg and add definition to it. While this feels unnatural, you need to make it second nature. Look at some shots of experienced fashion models to see this technique in action.

As for your hands, don't forget to place them delicately on the face for beauty shots and other close-ups. A palm flat against your cheek makes it look like you have a toothache. Most of the touching should be done with slightly bent fingers, delicately placed.

There are also poses that are so overused or silly that they should almost always be avoided. One of my personal (un-)favorites is where the model has her arm up and her face turned directly into her armpit, as if testing her deodorant. Whenever I see this, I involuntarily check the model's expression to see the results of her sniff test.

Occasionally you'll see a model go into a half squat with her knees far apart as if she is sitting on the toilet. This is just gross.

Finally, I will mention the much-dreaded "duck-face." This is when a model has her mouth slightly open and her lips puckered out like she is pronouncing the word "you" very emphatically. This may be some models' idea of a sexy pout, but the reason it has the name "duck-face" is because it looks stupid. If you find that you do it automatically when posing, you should immediately break the habit, or staple your lips to your gums.

The Photographer Is King

There is, of course, an exception to all of the advice in the previous sections: if the photographer asks you to do something, you do it. If he wants you to do a duck-face while smelling your armpit and going into a toilet squat with both your feet flat on the floor, you should consign your fate to the higher powers, hope sanity prevails when he sees the finished shot, and go into the pose with enthusiasm.

While the model has a creative role to play in every shoot (though some more than others), when your photographer asks you straight out to do something inadvisable, unless it's dangerous or outside your posing limits, you take a deep breath and give it all you've got. Hopefully you'll get a chance later to creep back and make him look good by slipping in some really excellent posing. (Of course, he'll take all the credit for the shots himself, but next time he needs to hire a model he'll undoubtedly remember the one who inspired him to do his best work.)

On the other hand, sometimes your photographer may be trying to capture something you don't see by asking you to do a pose that seems "wrong." One model I know has some small scars on her right cheek from where a dog bit her; she always automatically turns her left side to the camera. However, I've seen shots where the photographer insisted that she face the camera straight on or turn her right

side to it, and in some of these the scars paradoxically look fantastic, giving her face character and, if anything, a higher kind of beauty.

84

Chapter 9

Building Your Brand and Reputation

An old saying goes: "There's no such thing as bad publicity." A famous writer stated it differently: "The only thing worse than being talked about is not being talked about." These are clever sayings, but if modeling is your game, don't believe them for a minute. For models the more fitting quote is: "Image is everything."

In the modeling world there is something worse than not being talked about: being talked about negatively. In this industry you not only have to worry about getting noticed, but you have to make sure that you get noticed as someone photogenic, skillful, dedicated, and easy to work with. Photographers and casting directors have too many options to choose from to bother with slouches, phonies, or prima donnas. In the world of modeling, bad publicity is the kiss of death. So how do you assure that you are seen entirely in a positive light?

Branding

Your name and image are your brand, and you need to protect them like your flesh and blood. Huge companies spend millions of dollars a year protecting their brands; you should at least spend some of your valuable time. Monitor the Internet for discussions using your name (or names if you have a nude portfolio as well). This is both a good way to gauge your popularity and to identify falsehoods, rumors,

or misunderstandings about you that may need to be corrected before they spread far and wide. You should have a relatively high pain threshold here: you don't want to get a reputation as a prima donna who jumps on every criticism – but where career-damaging issues come up, it's time to step in with a polite but firm correction.

You should also search the web periodically for photos of yourself, using TinEye or a similar image search engine. Doing this, I've come across ads using my image, but for which I had not been paid. I've also found paintings I posed for on a commission basis being sold for upwards of a thousand dollars, but where my agreed percentage had undoubtedly gotten lost in the mail. In these cases, a polite reminder was enough to dislodge the missing payment, because the forgetful clients knew that I could easily drag them to court for such obvious violations of copyright or contract. But I would never have gotten this money if I hadn't searched the images. (This also illustrates why it's important to record your agreements in the form of signed contracts, and to keep copies of these.)

You can and should be more protective of uses of your pictures than of your name; people have an almost unlimited legal right to discuss you, but they have no legal right (outside of a news context) to use your likeness for profit (or even without profit under most circumstances) unless they have a contract or release giving them that right – and where the contract or release specifies that they will pay you, they are obligated to do so. Furthermore, under some circumstances allowing uncontrolled public use of your pictures can put them in the public domain – i.e., can waive your rights as owner, making them public property.

So you should be vigilant in monitoring the Internet for pictures of yourself. Authorizing reblogging with attribution for some images can be good business, but you need to be aware of how and by whom your images are being used. I've even had scammers and crazy little girls

make fake "Christie Gabriel" modeling profiles, which I had to have removed before they damaged my reputation.

Indispensable to branding are the social media sites; even big corporations have Facebook pages. You should participate in as many of these sites as possible at first, and scale back over time based on your experience with which are getting you work and which are not. I personally spend about 25% of my online networking time on Facebook and tumblr, but other models also find Twitter and other social sites useful. I would still limit the total networking time you spend on all social sites to 25% combined; spend the other 75% of your digital marketing time on industry-specific modeling websites.

At the beginning of your freelance career you should spend as much time as possible on online networking to build your name and get the word out. You know you're spending enough time networking when your modeling workload is increasing or you're getting as much work as you need. If interest in you begins to wane, you need to spend more time. (On the other hand, if you start turning into an Internet zombie, you may need to spend less time.)

If you shoot nudes, the challenges you face managing your brand online are more complicated. As I've mentioned previously, you need to keep your nude and vanilla brands strictly separate in the American market to avoid driving away commercial clients. At the same time, nude models are faced with a galaxy of choices in baring their work to the world. While art and figure nudes have always been my limit, there are many successful models who participate on more explicit sites (like Zivity, SuicideGirls, GodsGirls, and Deviant Nation). Navigating these waters requires you to know how you want your career to develop in the future, and what modeling markets you intend to target.

Word of Mouth

Especially at the beginning of your career, word of mouth reputation is extremely important, and now that every client has a worldwide megaphone to spread their delight or displeasure, word of mouth has more power than ever. For years my work was 40-50% repeat bookings, with another 15-20% coming from word of mouth recommendations. Since I've been free of agency politics, my percentages have increased to 75+% from repeat bookings, and almost all the rest from word of mouth. I'm now in a position where I don't have to actively seek out new clientele. Once in awhile I'll still spend some time drumming up business, but in general I can't keep up with all the worthwhile offers that find me. I attribute my good fortune to years of trying my very best to please my clients, and treating everyone on set – from the CEO to the lowliest gofer – as well as I can, and as potential sources of referrals. Also make sure you're easy to find, contact, and book online. All the good word of mouth in the world is worthless if the client has to jump through hoops to hire you.

The Shoot

So now you've gotten the job, vetted it, come to an agreement on terms, and shoot time is fast approaching. Now you can kick back and just go through the motions on set, right? Well, if you're smart, you'll realize that every minute you have with the clients is a minute you can either use to impress them or disappoint them. Remember, this isn't a situation where you can slack off one day and go on like nothing happened; this is about protecting your brand and building a stellar reputation, and about the possibility of repeat bookings and great word of mouth. We all have those days when we just don't feel like giving 10%, let alone 100%. I get that, but you can't cop out. To help me find my own inner strength, I've had success laying down ground rules and expecting myself to obey them. These are the five

unbreakable rules any model should follow if she expects to be considered a professional:

Rule # 1: Don't Flake

When you're nervous about an upcoming shoot, or simply not feeling up to par, it may be tempting to consider the idea that your grandparents have just died again, or that you've suddenly contracted the flu, giving you an excellent excuse to cancel. Worse, you may be tempted to take the avoidance route, and simply not show up.

The answer you'll have to give to these cowardly impulses is No. Flaking on a job you've agreed to do is the equivalent to your modeling career of stepping off the edge of the Grand Canyon. I'm a relatively well-established model, but the very idea of flaking gives me the shivers.

Think about it: a photographer has set aside a block of time when he could be hunched over his computer Photoshopping or doing whatever it is photographers do with their blocks of time. He has studied your portfolio to figure out what kinds of shots work best for you, and has come up with some ideas he's excited about; he has set up his studio or schlepped his gear out to some location; even worse, he or his client may have hired a makeup artist, assistant, or even an art director or wardrobe designer (who aren't going to give up their pay just because the model doesn't show); the anticipation mounts as the star of the whole production is eagerly awaited. But she doesn't show up.

What happens then? Do the photographer, client, and other professionals exchange lighthearted comments while they break down the set and equipment, reflecting fondly that you probably overslept or broke a fingernail, and vowing to double their efforts to hire you next time? Or do they grind their teeth in fury, swear never to hire you again, and resolve to warn their friends about you? Some otherwise quite rational photographers become extremely enraged

when they feel they've been disrespected in this way. And an enraged photographer can do a lot of harm to your reputation. As the saying goes: "Bad news travels like wildfire."

But what about if you really have an emergency? The answer is that for the professional model there is rarely a disaster that justifies canceling a shoot without at least several weeks' notice.

I sympathize with those of you who think you'd rather die than shoot when you have the period from hell. But don't blow your reputation on something like that. Instead, the day before the shoot eat lightly and go easy on the salt, which will decrease the bloating. Drink lots of water and absolutely no alcohol. Get as much rest as you can until shoot time. There's not much you can do about cramps, aside from over-the-counter medication. Be sure to take a full dose before the shoot, and have another one in reserve for when the first one wears off.

Obviously, you're going to need more bathroom breaks than usual; just try to pick times when the shoot is slowing down on its own anyway. Also, don't forget to bring scissors, especially on a nude shoot. Every time you change your tampon, you'll need to cut most of the string off.

Fight your way through the day as best you can with a smile on your face. Then go home, slam the door, yell at the dog, break up with your boyfriend, and continue being as bitchy as you want for the duration.

So you got through the menstrual shoot, and your fabulous performance there has landed you another gig. The problem is that now you've caught a cold, flu, or the bubonic plague. You can barely move; you have the unpleasant feeling that you're going to die in about five minutes, and your face has swelled up to resemble a large peeled potato. Surely you can flake now, right?

Wrong!

First, make sure that the client, photographer, and other team members know that they have the option to cancel if they're afraid to get your germs and follow you to the grave; however, never cancel on your own account unless you're in the hospital or under doctor's orders to do so. I once did four days of shooting in a frozen cornfield after being diagnosed with pneumonia. I don't recommend that, but it shows how seriously I take the rule against flaking. You won't get a good reputation by being a sissy.

Make sure you travel with all the medicines you may need to keep yourself upright under trying conditions. The drug industry has developed over-the-counter aids that greatly reduce most symptoms: Advil, Dramamine, Imodium, NyQuil, DayQuil, Chapstick, and cough drops, to name a few. Put lots of cold compresses on your face and eyes if you get puffy, drink buckets of water, and get loads of sleep. And again, fight your way through the shoot with a smile on your face.

Why is it such a disaster to cancel work if you're a model, even with a good excuse? Professionals in other fields can call in sick without negative consequences. Well, you can thank all the amateur "models" out there whose grandparents have died for the third or fourth time just before a job; as a result of their unprofessionalism, nobody will believe in your compelling reasons for cancelling anymore.

I myself lost a brother-in-law suddenly the night before a big shoot. I went to the in-laws' house that morning and tried to come to grips with the awful event before heading to the job. The easiest way to get through the shoot for me seemed to be to just focus like never before on what I was doing: what I could do to make my pose better, what pose would be next, how many different ways I could showcase the accessories I had on, and so forth. Through tragedy and sorrow, the show had to go on. And it did.

Rule # 2: Look Your Best

It should go without saying that if you hope to be a successful model, you must keep up on your physical appearance and personal hygiene. You don't need to look like a Giselle or Cindy Crawford, but you must take care of yourself. You'll need to be sure all of the following are checked off before shoot time:

- Is your hair clean and presentable?
- Are your eyebrows tweezed, and other facial hair in check?
- Are your legs shaved and moisturized?
- Is your bikini line properly maintained?
- Are your nails polished in a neutral color (unless advised otherwise)?
- Is your skin clean and moisturized?
- Are your eyes free of hangover red?
- Arrive at your shoot in loose-fitting clothes (preferably something that buttons or zips up the front so you don't mess up your hair and makeup upon removal)
- Be sure your deodorant can deal with a heavy workout

An extremely beautiful and accomplished model of my acquaintance works far below her potential for one simple reason: even though she develops significant body odor as she works, she doesn't wear deodorant. While she can do the most amazing poses and has a perfect figure, this has had an inevitably negative effect on her career. There is no excuse for bad hygiene.

If you're doing your own makeup, arrive with only the basics done (e.g., concealer, foundation) so that you have the flexibility to quickly adopt whatever look the photographer asks for (unless advised otherwise). Your

clothes – both the ones you wear and the ones you bring as wardrobe – should all be clean, wrinkle-free, and look good on you.

Rule # 3: Be Confident

There are two parts to confidence: feeling confident and acting confident. Feeling confident about something you're new at is hard, but it helps if you feel prepared. If you've been practicing your posing and have your model bag properly stocked and at the ready, and if you've been taking care of your skin, you'll feel more in control and therefore more confident.

Remind yourself that the client or photographer has decided he wants to shoot you, among all the other models he could have picked. That means he's sold on how you look already, which means that if you don't actively mar your looks or stand stiff as a stone, it will be hard to disappoint him.

You can add to this already good impression with a few easy body language tricks. Looking confident is a major factor in looking good, and looking confident is easy. One way is with posture. Show up to the shoot with your back straight and your shoulders rolled back ever so slightly. (Be careful not to overdo it, though, as you don't want to come across as snobby or unapproachable.) Try not to assume defensive positions, like crossing your arms in front of your body.

Don't talk too much, but when you do, make eye contact. Be friendly. Try to find reasons for a sincere laugh (or at least giggle) at frequent intervals. And smile. Most women know how to smile even when they feel like killing someone. Use this skill.

At least until you're more established in the industry, try to keep talk of your personal life to a minimum. Even if specifically asked about personal matters, keep details vague. Sharing too much drama will make you seem self-

absorbed or insecure. Be enthusiastic and full of good energy, but don't go overboard so that you seem hyper, or fall prey to nerve-induced speed talking.

Finally, don't pretend you know things that you don't, and don't be afraid to ask questions, as long as they don't interfere with the flow of the shoot. Just remember that the other people on the shoot know you're not a seasoned professional (you mentioned that on your profile, remember?), and that you will probably need some coaching. No one should (and most people won't) expect you to know everything right out of the box. Make sure to pay close attention to the photographer's instructions, as well as what the other models at the shoot (if any) are doing. Do your best, and not only will everyone be satisfied, but you'll learn a lot, which you can then apply at your next shoot.

Rule # 4: Be Positive and Cooperative
It's said that the great movie director Alfred Hitchcock used actors like talking mannequins: as long as they stood where he told them to and said their lines, he was happy. As a model, ideally you will bring fire and creativity to your work, but at a minimum you need to follow instructions to the letter and be prepared to exert yourself if necessary. If the photographer wants to wrap you up like a mummy, put a highly uncomfortable mask on you, and demand that you jump up and down in high heels, be prepared to do it until he feels he has gotten his shot. Ask for a break if you seriously need one, but make it short.

From the second you walk in until the moment you walk out, do not call, text or email anybody, and refrain from complaining about anything. Stay upbeat, enthusiastic, and professional at all times. Unless something the photographer asks you to do exceeds your limits, do the best you can to oblige. Photographers love models who put every

last ounce of their strength into trying to realize their vision, all the while maintaining a positive attitude, however difficult or unpleasant it is. Getting a reputation as a cooperative, positive, enthusiastic model is a powerful way to build your career.

Rule # 5: Don't Ask to Bring an Escort!

One thing that reflects the large number of amateurs on modeling sites is the continuing arguments that rage over whether or not models should bring escorts to shoots. While I can't give you advice on your personal security, I can tell you that professional models don't bring escorts to their shoots. Unless you're under-age, "reserving the right" to bring an escort can brand you as an amateur and also as a potential nutcase/diva. Would you take an escort to your job as a private secretary, or a psychotherapist, or any other job just because you will be alone in a room with a man for a period of time? In my opinion, you should vet your jobs thoroughly and carefully before you take them, and then treat this profession like any other.

If you set and enforce boundaries, you'll be leaving no room for unprofessional behavior. If you feel that someone is getting too pushy with you, if they're using disrespectful or derogatory terms when referring to your body parts, if they keep getting in your personal space, if they yell at you or throw things, or if they otherwise act inappropriately, then you need to use your best judgment whether to warn them that you're going to leave if it continues, or whether the time has come to actually leave.

If you make a big deal out of some small thing that is quickly corrected, your reputation will suffer, of course; but refusing to put up with disrespect or inappropriate behavior is not only OK, it's a big part of feeling comfortable working as a model at all. Furthermore, this kind of conduct from a photographer is rarely isolated, so you are unlikely to suffer professionally if you walk out of a shoot like this. Such a

person will know that if he tries to make a public issue out of your breaking off the shoot, he may get a blowback he can't handle from all the other models he's mistreated. Serious photographers are just as careful with their reputations as models, because at the end of the day, they depend on us just as much as we depend on them.

Chapter 10

Rising To The Top

There are crappy models, mediocre models, and even reasonably good models who will rarely get rebooked. There are also outstanding models, the ones whose clients can't get enough of them, the ones who are so solidly booked that they have little time to enjoy all the cash they earn. Once you've gotten a few jobs and the thrill of initial victory is starting to wear off, you'll start craving that higher level of respect, notoriety, and financial success.

This is where thinking outside the box, working harder than the competition, maintaining intense focus, and extreme dedication will pay off.

The Model As Trooper

After much negotiating and juggling of schedules, everything seemed finally set for a successful four-day shoot. A well-off hobbyist photographer had hired a team of 5 people (including me) to make his latest vision come to life. My part was somewhat challenging: I was to pose in the snowy forests and fields of northeastern Pennsylvania, wearing only black and gold tribal body-paint and brandishing ancient weapons that each weighed approximately a ton.

I had worked with body-painters before, so I knew I was in for hours of standing nude while being blasted with cold puffs from a compressed-air gun. In this case I would

also be going straight from this merely cold painting process into seriously freezing January weather. I knew I could do it if I just put my mind to it and kept myself in top shape leading up to the shoot.

The problem was that instead of being in top shape, I had gotten pneumonia.

My doctor had ordered a course of killer antibiotics and bed-rest for a week. But a whole team of people had made plans around this shoot, deposits had been paid, and I had a reputation to consider. Realizing that some people would rather lose thousands of dollars than risk getting sick, I contacted everyone involved to warn them of the danger of infection. I assured them I would give 100% if they still wanted to go ahead with the shoot, but I'd also understand if they wanted to cancel. Everyone wanted to proceed as scheduled.

My sinuses, lungs, and ears alternated between intense tingling, pressure, and sharp pain on the flight to Pennsylvania, and my stomach was trying desperately to get rid of the antibiotics I had poured into it. A thick layer of lanolin and Vaseline coating the broken skin around my nose and mouth made me look like a burn victim. As soon as we landed, I trudged to the bathroom to clear my sinuses and replace the shiny lube on my face with concealer.

I fought my way through the next few days somehow. As luck would have it, the heat in the studio was on the fritz, and standing on the freezing concrete getting riveted by the pressurized coldness of a paint-gun for three and a half hours made me want to throw up, cry, and pass out, not necessarily in that order. Instead, I tried to stay focused, laughing and joking with the other team members. After a few test shots inside, it was out into the absolute torture of the subzero tundra to hold up heavy iron objects that my hands froze to. All the time I pushed myself, trying to impress with every pose. I look back on those hours in the

snowy fields as among the most unpleasant in my career, but to me the torture was worth it.[2]

It's no secret, of course, that photographers love models who work hard to realize their vision. But some models will go much farther beyond the call of duty than others. For example, one model whose reputation precedes her walked two miles in pouring rain to an auto parts shop when her car broke down on the way to a shoot. She then walked back to the car, fixed it, and showed up only twenty minutes late. I know this because her grateful photographer posted an ecstatic review on one of the modeling sites I use. I predict that this model will never be short of work.

A great model is the polar opposite of a diva. She cares little for her own comfort (though she does look after her safety), and doesn't see herself as the center of attention, much less a pampered star. She's a dedicated team member, who makes her client's problems her own problems, and her client's desires her desires. This means that she not only acquiesces in the client's professional requests, but actively uses her brain, willpower, and strength to help the team grab the prize they're after: The Shot.

Being a trooper is a sure fire way to rise above your competition. When people who've worked with you start posting reviews about your amazing level of dedication, you know you're on your way.

The Model As Jack-Of-All-Trades

Which brings us to the next quality of great models: resourcefulness. This springs from the same can-do attitude as being a trooper, but goes farther, because here the model reaches out beyond her expected role to rescue or improve a shoot. A good model is always well prepared for her

[2] I survived going against doctor's orders, but I can't recommend such a practice. If a healthcare provider ever instructs you to cancel a job, remember to supply your client with proof in the form of a doctor's note.

assignment; but a great model tries to be prepared for the unexpected as well. For example, when a vital member of the team cancels at the last moment, it can ruin the shoot. But it doesn't have to. You should be able to save the day much of the time.

The most straightforward way to rescue a shoot, of course, is to make yourself available if another model doesn't show up. Say you were only hired to do a couple of headshots, but the lingerie model flakes; offer to slip into the skimpy wardrobe and carry her part as well. Even if the particular type of modeling is outside your expertise, do your best; the client will love you for it.

Try to prepare for other unlikely but foreseeable scenarios as well. Say the makeup artist doesn't show up. Well, luckily you've come prepared with your own full makeup kit and your semi-pro makeup skills. It's the same drill in case the hair stylist forgets to make an appearance; you just happen to have your hair kit as well.

Where this save-the-day stuff gets trickier is when you have to play wardrobe stylist. Obviously, if a shoot is for a specific designer's clothes and the stylist fails to show up with them, there's nothing anyone can do. But if the shoot is, say, for portfolio development, you may be able to help. Normally you'll be told in advance what kind of wardrobe will be used on the shoot. It's always a good idea to bring along some extra clothes that fall into the same theme. If the plan is swimwear, pack a few swimsuits and beach cover-ups. If the stylist is scheduled to bring some evening gowns, pack a couple of old bridesmaid dresses, some elbow-length gloves, and a little jewelry. Then if the stylist doesn't show up, you can pick up at least some of the slack.

Now, just because you're prepared for these emergencies, don't think your preparation is "wasted" if all the team members do show up and everything goes as planned. Don't feel that you have to get the team to use any of your items or recognize your foresight. You can, of course,

help out with the items in your bag of tricks if they ask you – but only if they ask. Believe me, one of these times your preparations will pay off, and then you'll be a star in your client's eyes.

So be a jack-of-all-trades to the extent you can without seeming pushy or inept; this is just another way of being active and taking personal responsibility for each shoot, great or small.

The Model As Creator

One of the most important ways a model can contribute to a shoot is by adding her own knowledge and creativity to the mix. Of course, in order to do this effectively, she has to (1) have some knowledge and creativity to offer, and (2) be able to gauge to what extent she should step forward to offer it.

What I mean here by "creativity" is the ability to see possibilities in the ingredients of the shoot – the background, props, wardrobe, lighting, theme, etc. – that no one else has seen, and the ability to turn this insight into a practical strategy for the shoot.

A simple example: I was doing an art shoot in a hotel suite with a hobbyist photographer who was having me pose on various pieces of furniture. As far as I could tell, he was satisfied with the shots we were getting, even though they were fairly standard hotel room photos, not particularly exciting or unusual. But in one of my poses I happened to glance up and see a wooden ledge above the head of the king-size bed. It held upward-facing recessed lights providing indirect illumination on the ceiling.

I pointed at it. "What if I get up there?"

The photographer looked at the ledge, then back at me, and a wide grin came over his face.

"Awesome!" he said.

He helped me up and I posed in the space between the ledge and the ceiling, lit from below by the recessed

lights. The shots we got are quite unusual, and are also some of the most eye-catching in the photographer's online portfolio, garnering a lot of attention. It goes without saying that I am now on his short list of "go-to" models he calls when he wants to do a shoot.

Now, I have no special training in set design or lighting, but I do try to keep my wits about me while I'm on a shoot. There's always a temptation to zone out and go on autopilot when you're working with photographers who aren't very demanding or dynamic. You have to resist this easy path, and remain engaged. For example, this shoot would have brought me no sense of impatience if I had been just going through the motions. Fortunately I did feel a sense of impatience, because I knew that if the end result was as mundane in the photographer's eyes as I was sure it would be in mine, he would think twice before rebooking me. This prompted me to keep my eyes open for alternatives; otherwise I would have gone through the shoot just as oblivious to that ledge as the photographer.

While by definition there is no recipe for creativity, there are ways of producing the conditions that can activate it. First, remind yourself that if your shoot is successful and produces unusual and creative results, that's just as much a reflection on you as it is on the photographer. This motivates your subconscious mind to keep its wheels turning, looking for possibilities.

Second, remember to stay alert and engaged. While the photographer is directing you, your attention should be on following his instructions with intensity and focus. But there are always pauses, ranging from a few seconds while he curses and fiddles with his camera to longer breaks for set changes or snacks. When you have a minute or two, take a look around the space you're shooting in, just to see what's what. Think about the possibilities. Give your brain the input it needs to get creative.

Third, don't try too hard to be creative. Just be receptive to the creativity that may bubble up from your subconscious. The creative part of the brain works best by stewing in its juices, not by being pushed. If you're alert and engaged and have a strong desire to make the shoot successful, that's all the urging your brain needs. Under those conditions, if there are ideas to be had, you will probably have them. If you don't, no problem; you'll still be able to do your primary job.

Fourth, have faith in your ideas and impulses, and don't be afraid to try things that seem far out and even un-model-like. Of course a lot of the things you come up with won't work, but that's true of even the most creative genius in the world. If you have the brains and drive to be a good model, your ideas are likely just as good as anyone else's.

Now, all of this has one great big caveat: there are many times when your creativity may not be called upon, or when it may only be called upon within the narrow range of the types of poses you're asked to do. This may be the case when you're working on a project with a very specific goal, or with a photographer who wants complete control and has a clear idea of what he wants to do. Getting too creative or independent when it's not called for will simply annoy experienced professionals and make some less-experienced clients feel defensive.

You have to make a judgment call here, and be willing to back off or step forward depending on the photographer's reaction. On the one hand, I have all but taken over shoots where newbie photographers were still learning the basics, trying to give them the wardrobe and poses I thought a professional in their shoes would want. On the other hand, a friend of mine who has been a professional photographer for two decades barks detailed instructions at me when we shoot and I follow them to the letter, making myself his marionette.

A great model is creative, but she knows when her creativity is needed and when it's better kept in storage.

The Model As Actress

We'll call her Ellen, though that's not her real name. She's in her early 20's, is 5'4", and weighs 100 pounds. Her face is pretty but not beautiful, her figure is slightly dumpy, her hair is a mousey brown. She's one of the most sought-after freelance models in the country, charges a hundred dollars an hour, and shoots nearly every day, often with top photographers in major cities.

Now compare Ellen with the thousands of gorgeous, toned freelance models who can't get enough work to quit their day jobs. What's going on here?

In Ellen's online port there is a picture of her wearing a plain dress and shouting at the camera like an insane person; in another she lies in bed with another girl, hugging her sweetly. Many of Ellen's pictures are electrifying, haunting, sometimes even frightening, in others she is all innocence or sensuality. Whatever the shot calls for, she plays the role convincingly.

Now look at the ports of some of her prettier competitors. They pose smiling at the camera in swimsuits or show off their T&A in glamour nudes. Some of their shots are colorful, involve beautiful clothes, or are nearly pornographic, yet most of them are completely forgettable.

What's the difference? How is it that the ordinary-looking mousey little brunette clearly outguns the toned, leggy beauties?

The answer is that Ellen is an actress, and her focus is always on the role she's playing for each shot. In their pictures, the less successful models seem to be saying: "Look at me!" In her pictures, Ellen says: "Look at this picture!" Paradoxically, by focusing on what the picture needs, Ellen becomes great; while the others, by focusing on themselves, unintentionally make themselves boring.

A great model will realize that the shoot is not about her; it's about the scene, or the clothes, or the idea she's been given by the photographer or client. She works to fit herself into the picture, rather than trying to make the picture work for her.

Another thing about Ellen's work is that she's amazingly sexy – seemingly without trying. It's important to recognize that, especially when it comes to sexuality, subtle is usually better than blatant. Usually the best way to project sexiness is through confidence, not through posing. Simply ignoring the fact that you're sexy and focusing on the task at hand is much better than flaunting your T&A as if you're trying to catch the attention of the astronauts on the Space Shuttle.

But how do you effectively make yourself the character that The Shot needs?

How To Give a Killer Performance

An actress who tries to draw attention to herself rather than carry her part in the plot can ruin a movie, and the same thing is true for photographs. To be a great model, you have to push your personal self into the background, get in character, and stay there for as long as it takes.

This is often simpler than it sounds. Sometimes your photographer or client will tell you the story behind the shot, whether it's a commercial shoot where you're supposed to portray someone in a real-life situation, or an art shoot where you're supposed to project some strange, extreme, or subtle emotion. Such shoots are often the easiest because there is a clear goal laid out – but at the same time they tend to be the most creatively restrictive.

Other times, though, you'll get no such input, and will have to rely on your own wits, as well as your storytelling and acting skills.

For example, say the shoot is set on a rocky seashore. You're given a ragged peasant dress and asked to pose on a boulder with the pounding surf behind you – but your

casual questions about the story behind this scene are met with blank stares. What do you do? Sit on the rocks and let the photographer take pictures of you, reflecting that it's his own damn fault if he doesn't have a clearer idea of what he wants?

Wrong.

Without making a big deal out of it, a great model will fill in where the photographer has fallen short. You'll make up your own story, and make yourself the heroine of it. You've been stranded on these rocks after a shipwreck; or you've come here to throw yourself from the cliffs because your lover has died; or maybe you are the incarnate spirit of this place, beautiful, wild, and lonely. You pick the story you think is most appropriate to the scene or to what the photographer seems to want, and you start to act that out with all your might and skill. For example, if you picked the spirit of the place theme, you might stand barefoot on top of the rocks, gazing out to sea, your face calm and sad. If you picked the shipwreck theme, perhaps you lie on the rocks as if something in your body has been broken, exhaustion and grief showing on your face.

Now, once you start silently acting like this, one of two things will happen. Either the photographer will love it and start pushing his little button like mad, or he'll take his eye away from his viewfinder and give you a direction. "No, face me," or "Can you look more cheerful?" or "Don't lie down, stand up," etc. The first outcome means that he likes your story and the character you've decided to play; the second means that you should pay attention to his directions and try to figure out what story he wants. You may go through several different stories before the sound of the shutter firing is all you hear over the surf. Your photographer may also want one story for a while and then want to switch to another.

Even if you never exchange a word about "the story" or "your character," listen carefully to what the

photographer does say for hints as to what story he has in mind (whether he knows it or not), then try to imagine it and act it out. Once you hit the right story, you'll feel the elation that comes with falling in sync with your concept and photographer; in fact, you may want to squeal happily and jump around – but don't break out of character!

Some people are born actors, and they take to it like little kids playing make-believe, but most of us have to work at it. If you fall into the second category, I recommend studying the basics of Method Acting. Method Acting is described in Wikipedia as "a family of techniques used by actors to create in themselves the thoughts and emotions of their characters, so as to develop lifelike performances. The 'method' in Method acting usually refers to the practice by which actors draw upon their own emotions and memories in their portrayals."

The Method approach works best for me, but there are many other acting techniques, and something quite different may work for you. The point is to use whatever works to create a lifelike "performance," even if you're simply walking the runway or holding up a tube of hand-cream.

Versatility is an important quality here. Because you'll be called upon to be part of so many concepts, images, and themes during your career, you must be able to portray a wide range of emotions believably.

The Model as Muse

Outstanding models often reach a point where they become the "muses" of photographers and other artists. The ancient Greeks thought that the Muses were goddesses who inspired the creation of art, and some people still believe that there is a semi-mystical relation between the artist and his or her muse. Aside from the model's satisfaction at inspiring and helping to create art, there is the additional benefit of

constant rebookings. Thus from both an artistic and financial perspective, being considered a muse is a desirable thing.

In my experience, the models most often chosen as muses are those who cloak themselves with an air of mystery, and at the same time are highly creative. The sense of mystery I'm talking about here is often a kind of emotional blankness or ambiguity that makes the model a receptive screen on which the photographer or artist can project his own unconscious ideas and fantasies. As for the model's creativity, this often seems to spark the photographer's own creativity, inspiring him to try things he has never tried – or even imagined – before.

To be a muse, you need to keep a certain emotional detachment while at the same time maintaining an intense creative rapport with your photographer. For example, say you are asked to pose with a chair. You already know enough not to just sit in the chair and wait for the photographer to tell you what to do. Let's say instead that you and the chair put on a high-intensity show. You can sit in it regally one moment, then curl up in it like a wounded child or sleepy kitten, jump off it, flip it over, drape yourself backwards over the arm of it, incorporate it in a quest to form as many geometric shapes as possible. You're feral, then innocent, elated, melancholy, then just a being of shapes and lines. It's as if you're acting out an evolving brainstorm.

This is similar to the "model as creator" quality discussed previously in this chapter, except that it is both more personal and more detached: more personal because an intense rapport between photographer and model is crucial to the artist-muse relationship, and more detached because while the model lets her creativity run free, she also remains impersonal, almost as if she is not being creative herself, but letting a kind of cosmic creativity play through her.

* * *

If there are any surprises in this chapter, they're mostly for those who still see modeling as primarily a passive undertaking. The fact is, rising above the vast middle ranks of the modeling market is hard work, requiring creativity, energy, and drive. You need to make sure that you're always over-prepared, that you have an almost obsessive sense of responsibility for the shoot and everyone involved in it, and that you are ready, willing, and able to convincingly and compellingly turn yourself into whatever character or vessel is necessary to get The Shot.

Chapter 11

Niche Modeling

When most people think of modeling, they think of fashion/runway work. In fact, the largest single segment of traditional modeling falls into the commercial category, i.e., selling ordinary products and services such as department-store clothes, cars, housewares, restaurants, alcohol, food brands, and similar things. Fashion/runway modeling generally comes in second, followed by beauty, and lastly glamour.

However, the proportion of the playing field devoted to less traditional genres has grown rapidly, and seems likely to continue to grow. Many of these "niche" markets are not served by the traditional agencies, which leaves even more opportunities for freelance models.

Plus-Size Modeling

A lot of media attention has been focused on plus-size modeling recently. It is certainly a positive to have fashion and commercial images finally coming into closer alignment with the reality of the average body-type. What is less talked about is that this kind of modeling is very hard to break into, probably because of the same stereotypes that have kept curvier women out of the spotlight for so long. Prospective plus-size models are scrutinized more strictly on virtually every other aspect of their appearance – face, skin, legs, and

proportionality of figure, etc. – than their thinner counterparts.

To be a plus size model you should be a size 12-16, with a proportionate figure; sizes 10 and 18-20 are also used, but less frequently. Plus-size models do mostly fashion/runway and commercial modeling, but a certain (smaller) amount of plus-size beauty and glamour modeling work also exists. However, outside the explicitly plus-size markets, these models have a hard time landing work.

Plus-size work is almost entirely obtained through agencies; freelance models will have difficulty in this area unless they are open to nude work. The remaining cultural prejudice against curves means that even agency-represented plus-size models get less work than their thinner counterparts. All in all, the industry is tougher on these models, so a plus-size girl must have thick skin.

Body-Part Modeling

Like plus-size modeling, body-part modeling is what might be referred to as a "mainstream niche," meaning that the market is well-developed, and most models who do it are agency-represented. Hands, legs, and hair are the parts of the body most frequently used in this niche, though many hair models are also required to have appealing faces.

Hand models mostly display jewelry and nail polish; this market favors long, slender hands, long fingers, and long nail beds. But it's not only nature that makes a successful hand model. While women typically pamper their faces, their hands are often exposed to unfriendly household chemicals and undergo frequent washing with harsh soaps. If you want to be a hand model, you need to treat your hands at least as well as your face. Exfoliate them, treat them with anti-aging serums, and use SPF 30 cream frequently during the day. Remember to wear gloves during windy and/or cold weather, and also while doing house- and yard-work. Keep your nails protected with polish, and maintain a

calcium-rich diet; not only will it benefit your nails, but calcium is a vital nutrient for your skin as well.

Leg models mostly display hosiery and shoes; the demand here is for long, slender, shapely legs with smooth, uniform skin. Some muscle tone is also desirable, but not to the extent that your legs look at all masculine. While Photoshop and other post-processing can improve shape and erase flaws, it's still best not to have too many tomboy scars, bruises, or scrapes. Improper shaving can also cause problems. Remember to shave in the direction of hair growth, and to apply a protective skin cream in the same direction after shaving. This will go far to safeguard you against ingrown hairs.

Hair models are most often used for hair product campaigns or hair salon advertising. They can also get work doing hair and beauty shows. Beautiful, well-maintained hair is obviously a requirement here, but so is a willingness to sport wild haircuts and colors.

There is some modeling work out there focusing on other body parts as well. Foot models are often sought after, but most of that work falls more into the fetish arena.

Pregnancy Modeling

Pregnancy doesn't mean you need to suspend your modeling career for nine months. There are maternity clothes, maternity stores, pregnancy magazines, and pregnancy products – and therefore, of course, pregnancy models. Because 80% of American women have a child at some time in their lives, this is a large market, though mostly invisible to people who aren't in the relevant condition. Some fine art photographers are also interested in pregnancy models.

One thing about pregnancy modeling, though, is that to do it you have to be unmistakably pregnant, and not at the stage where you look like you might simply have been

eating too much rich food. That is, during the time from when you start to show until you have an obvious baby bump, you'll probably find yourself limited to beauty and body part work.

This doesn't mean you should wait to set up your shoots. The key to pregnancy modeling is preparation. Most women don't like to announce their pregnancies until the third month or so, and with good reason – but this is often too late if you're looking to get any maternity work. As soon as you learn of your condition, you need to start contacting photographers and looking into casting calls immediately, or contact your agent if you're represented. It can often take months to line up a shoot, and you don't want to miss your window of opportunity. Once you get to the obviously pregnant stage, commercial work will be your mainstay, selling products from maternity clothes to baby paraphernalia.

The pregnancy field is just as competitive as mainstream modeling, and the pay is on par as well. You can get this kind of work either through agencies or freelancing. Remember too that while you're pregnant you'll want to keep a lighter-than-usual work schedule.

Fitness Modeling
Because of Americans' increasing interest in getting in shape, the market for fitness models is large and potentially lucrative, with pay comparable to what other commercial and promotional models make. Fitness models typically do ads for swimwear, sports and exercise machines, as well as fitness videos. They may also do stunt-double modeling, though this often requires specialized training and experience. On the downside, while fitness modeling is easy to break into if you have the physical qualifications, it is extremely competitive, so it's hard to climb the ladder to success in this genre.

Fitness models must have good muscle tone and definition, and relatively low body fat ratios. The preferred look for all but a narrow segment of female fitness models is toned but still very feminine. Female fitness models should refrain from sculpting themselves into body-builders unless going after that specific market.

The preferred height range for female fitness models tends to be shorter than for many other types of models, generally between 5'6" and 5'10". Facial beauty is still a plus, and this type of model must be especially careful not to get so thin that her face looks gaunt, or so pumped up that her face looks masculine. This means that artificial (and illegal) bodybuilding supplements such as steroids must be avoided, both for their negative health impacts and for their "masculinizing" effects.

Nude Modeling

We now come to a lucrative area of modeling that is almost exclusively the preserve of freelancers. To protect their images in the mainstream American marketplace – where nudity is still officially taboo – many commercial clients and fashion brands do not want models who pose nude in any context representing their products. In turn, because these commercial clients and fashion brands make up the bulk of agency business, most agencies don't represent nude models. (In fact, you should be very cautious of any "manager" or "agent" who offers to represent you in this kind of work.)

At the same time, this is a huge market, bolstered by the enormous number of hobbyist and aspiring photographers that now populate it. Because the clients are usually individuals rather than companies, the pay is not as high as it is in the commercial sector. It's still good though, and the work is abundant enough that you can make a living at it.

If you're of age and comfortable being nude in front of people you don't know, this may be the category for you.

Nude models are booked for everything from hobbyist photographer projects and art classes to men's magazines. And it's relatively easy to become a nude model: the facial requirements are generally not as strict as for many other types of modeling, and the figure requirements may also be somewhat relaxed depending on the context. For glamour nudes it helps to have a petite yet curvy figure; this is not nearly as important if the work is more art/abstract-oriented. However, for art nudes a high degree of physical flexibility is preferred, as you are often asked to assume pretzel-like poses. A background in dance is highly beneficial to the art nude model, because it provides this kind of flexibility as well as good definition and the ability to hold difficult poses gracefully.

Models who sit for painters or sculptors must be able to hold a pose for long periods of time; however, that aside, this may be the easiest kind of modeling, as you need not memorize many poses or learn to make your poses flow in response to the rapid shooting that digital cameras encourage.

Alt Modeling

Like nude models, alt models are generally not represented by the established agencies, though in recent years a few smaller, specifically "alt-oriented" agencies have sprung up. (These, of course, should be approached with the same level of caution you would use in evaluating any small or startup agency; see Appendix 2.)

The market for alt modeling is large and growing. Another advantage, at least at this stage, is that the physical requirements are less stringent than in most other genres.

The variety of alt modeling sub-genres is very large, and it would be impossible to discuss them in any detail here. They include alt fashion genres like Goth and Punk, alt glamour genres like Pinup and Burlesque, and alt nude genres in various degrees of unconventionality. Body

116

Modification and Cosplay have no equivalents in mainstream modeling, and are almost by definition limited to girls who are already members of those communities.

In fact, in all alt areas a big advantage will go to those who are already members of the alt subculture in which they wish to model, because they will already be familiar with the styles and other conventions. This doesn't mean that "outsiders" can't be alt models; they'll just need to do their homework.

Participation in some alt modeling subgenres – like alt fashion – will generally not affect your ability to work in other areas of the industry or obtain agency representation. Others – especially some of the more unconventional alt nude and fetish subgenres – will likely prevent you from working in the commercial/fashion mainstream. Subgenres that involve physical modifications, such as large tattoos or unconventional piercings, will limit your ability to obtain mainstream fashion, commercial, or glamour work simply because of the departure from a "natural" appearance.

Fetish Modeling

Most people consider fetish to be a subgenre of alt, but it's large enough that it is often discussed separately. Fetish models display fetish fashions or devices, or play characters in fetish-like situations. Fetish fashions include latex clothing, PVC, corsets and other unconventional wardrobe, and highly stylized or fantasy-based clothing such as body armor or costumes. Bondage and foot fetishes also make up a large chunk of the work in the fetish market.

This market is large and relatively easy to break into, the physical requirements are more relaxed, and the pay is generally good. There is certainly enough work available in this category to allow you to make a living. Keep in mind, though, that the actual posing and concepts in fetish work range from innocuous and mainstream (e.g., modeling full-length rubber wardrobe) to bizarre (e.g., "sock-sniffing") to

what many people would consider repulsive. You must be sure you're comfortable with at least some of these themes if you expect to earn a living solely from fetish work. It goes without saying that any model signing up for a fetish gig should take care to fully understand the photographer's/client's intended project, as well as making clear her personal limits in terms of posing, etc.

Fetish models should use pseudonyms and keep them entirely disconnected from their real names if they hope to work in traditional modeling genres as well.

Real People Modeling

"Real People," "Lifestyle," or "Character" modeling is a commercial niche for advertisements featuring average-looking people of all ages and types, usually to sell everyday mass-market products. There are few physical requirements, except that you look ordinary, approachable, and like someone people can relate to. This is a large market, but because the pool of potential models is so vast, it is not necessarily easy to get work. The pay is generally good, though less than what mainstream models make. If you're looking for a serious creative outlet, you should also know that the work here is generally bland and unexciting.

Some agencies have Real People divisions, while some only handle Real People models.

Promotional Modeling

Many consider this the lowest rung of the modeling world. A promotional model (sometimes referred to as a "spokesmodel") is basically an ornamental sales-girl, often at a makeshift portable storefront, a booth at an industry convention, a car- or boat-show, or similar event. The good news is that this niche is large, easy to break into, and the physical requirements are relaxed. The bad news is that the pay is poor and the work is often grueling and sometimes infuriating, as it involves trying to sell to (and being nice to)

the public. Of course this means sales and customer service experience are helpful.

This low-paying work is of little interest to most agencies, so the field is wide open to freelancers. However, as these gigs are a lot like retail sales jobs (and the pay isn't much better), you may want to consider promotional/spokesmodeling as a day job that you can hold until you start getting other modeling work. The exception to this is if you land a spokesmodeling contract making you the face of an international or other major brand. In such rare cases you are almost certain to receive a very substantial rate of pay!

The Changing Landscape

Even outside the niche markets, a unique appearance or skill can make you stand out and attract work. There are models who shave their heads, cultivate an androgynous look, or are skilled in ballet or even trapeze. The industry today emphasizes variety more than ever before. The all-American girl look reigned in the 1980's; in the '90's heroin chic brought the skeletons out of the closet; in the early 2000s all the most successful models seemed to be the ones with curves. However, since then things have been shaken up, and from where I sit it's beginning to look as if the days of creating molds for models to fit into are behind us. Just open a Victoria's Secret catalogue or sit through a couple of shows at Mercedes Benz Fashion Week, and you'll see what I mean.

To many veteran models, this new environment has been a breath of fresh air, allowing us to branch out in directions we could never have taken before. It's also a blessing to new models, because there are so many ways to break into the industry.

My own career started with fashion, and though it was fun and lucrative, after a few years I yearned for more variety. The new, exciting world of modeling has allowed me to experience that variety while still making a good living. One day I'm shooting fashion in New York, the next

it's off to the West Coast for some glamour work, then back to the Midwest for some creative art shoots with old friends. It's easier to keep your schedule full and your brain engaged when you make yourself versatile. With hard work and dedication, that versatility, and the satisfaction that comes with it, is easier to achieve now than ever before.

Chapter 12

Preserve Your Beauty and Health For Career Longevity

If there were a list of the creepiest things about our culture, the obsession with thinness would have to be near the top. If you read this stuff in a science fiction novel, you'd think it was too far out: psychological illnesses where people literally starve themselves to death; websites (the so-called "pro-ana" sites) where the afflicted socialize and urge each other on in their self-destruction; celebrities girdled and even duct-taped beneath their gowns. The ability to store fat quickly and give it up slowly is an evolutionary adaptation that kept our species alive for thousands of years when food was scarce, yet this natural, healthy ability is today treated like something worse than leprosy.

Fortunately, this obsession is gradually losing its grip. With the increasing use of plus-size models and the many niche markets in existence today, it's no longer necessary to be skeletal to get work. Take a look through fashion magazines, commercials, and fine art books. Body types, ethnicities, and looks vary greatly. But there is one thing all these models do have in common: I challenge you to find a successful model who looks unhealthy. Even the too-thin models are made up and dressed to look vigorous and strong.

The one nearly unbreakable appearance rule for models is that you have to look healthy. And if you're older than about 16, the only way to look healthy is to be healthy. The good figures, clear skin, shiny hair, and bright eyes people admire on the pages of magazines are the results not of starvation, but of good nutrition, adequate rest, exercise, and little or no alcohol or recreational drugs. Many young models give little thought to their health, but as someone who is approaching a dreaded age numeral, I can tell you that relying on your looks while burning the candle at both ends may work for a couple of years, but it won't work forever.

The great thing about good health is that it is attainable by nearly everyone. Maybe you weren't born with perfect genes, but your eating habits, exercise patterns, sleep schedule, and recreational tendencies are under your control.

So to those hardy few who are willing to bust their asses to be models, I offer you this challenge: get healthy. If you represent the very best of your body-type (whatever it may be), I can almost guarantee you a good amount of modeling work.

Premature Aging and Poor Health Are NOT Strictly Genetic!

How is it that people age so differently? There is certainly a genetic component, but on the other hand, even identical twins can age very differently. While there's not much you can do to change the genes you were born with, there's plenty you can do to influence what scientists call the "environmental component" of aging. The especially "high mileage" types who look much older than they should usually either smoke or drink heavily, embrace the nightlife, or live on Hostess Cupcakes and TV. But even without making such extreme mistakes, there are many factors we expose ourselves to every day that can accelerate the

deterioration of our looks. This is especially bad news for models.

Luckily for us, the signs of aging can be slowed down and sometimes even reversed. A lot of this has to do with skin health, but since skin health is part of general health, a holistic approach should be followed.

Factors That Age Us, and How To Fight Them

Stress

When we're under stress, our bodies do two things that are bad for the skin. First, we produce more of a male hormone called androgen, which activates oil production, leading to blocked or enlarged pores, blackheads, or acne.

Second, stress also causes skin dullness. During acute stress (like when some jerk cuts you off in traffic) the body's "fight or flight" response may be triggered, even though such a response doesn't make much sense on a freeway. All your body knows is that you've had a strong emotional reaction to something, and it assumes this means you need to be ready to hit someone or hit the road. In order to support this program, nutrient and oxygen-rich blood that would normally go to the skin is redirected to the muscles and vital organs. This temporary malnourishment of the skin not only causes a lackluster appearance, but will also aggravate any conditions that already exist (such as acne, rosacea, hives, fine lines, eczema, and damage to the barrier function).

Many books have been written about how to lower your stress levels, prescribing many different solutions. This is a good thing, because what works for one person may not work for another. A good friend of mine uses daily meditation followed by vigorous exercise. I find nothing more relaxing than a massage followed by a lavender bath soak with a glass of hot chamomile tea. (Lavender and chamomile are both known for their soothing properties and

promotion of peaceful sleep.) Many people find that they can reduce stress by reducing the number of unnecessary obligations they accept, or by refusing to unnecessarily put themselves in stressful situations (such as driving in rush hour).

However you do it, though, lowering your stress levels is probably the single most important thing you can do for your health.

A model's life can be stressful. The strain of frequent travel, long hours of hard physical work, and being nice to everyone all the time can take its toll. You shouldn't wait until your stress levels become unbearable to find and start practicing a stress-reduction technique that suits you. You'll probably notice an almost immediate improvement in your appearance (and how you feel) even if you weren't aware you were under stress in the first place.

Smoking
Smoking damages the skin so much that a dermatologist coined the term "smoker's face" to describe it. Because thousands of cigarette toxins are carried into the skin via the bloodstream, collagen levels are quickly depleted, which causes wrinkles to deepen and facial tone to diminish. Smoking also thins the skin, making the underlying veins more visible. Depletion of collagen and skin-thinning makes smokers' faces look sunken, exposing the bony structures under the surface, while also giving the skin a grayish hue. And this is just your skin! Smoking also has bad effects on your hair, teeth, and nails. (This is not even to mention what it does to your lungs and other organs.)

I'm not going to tell you that you have to quit, but I will say that the less you smoke the slower you will age. Whenever you see a beautiful young model smoking, you can bet she hasn't been doing it very long; come back and look at her in three years and you'll be shocked by the

changes you see. Quitting also cuts your chances of getting cancer by something like 50%. Enough said.

Dehydration
With proper water intake, your body more easily absorbs nutrients and expels toxins. Circulation improves, helping transport nutrients and oxygen to the skin. With this consistent nourishment the skin stays supple, clear, and soft.

On the other hand, without enough water your skin suffers. Being chronically thirsty is viewed as an emergency by your body, and it responds the same way it does to stress: the skin becomes the last priority for nutrient and oxygen delivery until the crisis is remedied. Dehydration is behind many cases of eczema, acne, and dandruff, and is a leading cause of prematurely aging skin.

Try to drink at least six to eight glasses of water a day. I know it's not the most exciting beverage, but there are ways to jazz it up. Throw in some lemons, limes, or berries; alternate between that and chamomile or naturally decaffeinated green tea. Turn to raw fruits and vegetables if you're still having problems drinking your water; most of these foods are over half water.

Inadequate Sleep
During sleep, your skin's ability to repair itself is at its highest level. Absorption rates increase due to the decrease in sebaceous output (oil production) during the night hours. This is why it's important to wash makeup off and replace it with something you actually want your skin to soak up before going to bed.

Because of this skin repair function, it's important to try to get plenty of shut-eye. If you deprive yourself of adequate sleep, not only does your skin have less time to repair itself; your immune system also suffers. With weakened immunity, you open yourself not only to more bacterial and viral skin infections, but your body's response

to stress will be more extreme, and thus more damaging than normal.

A hundred years ago, the average American slept 11 hours a night; today the average is 6.7 hours. Chronic sleep deficits have been blamed for everything from heart attacks to automobile accidents; and will also give you that haggard, hollow-eyed look. I aim for at least seven hours of sleep a night, and when this isn't possible I make up for it the next night by refusing to go with less than nine hours. Naps on airplanes, on trains, and squeezed in between shoots can sometimes be lifesavers. The ability to sleep anywhere is a valuable skill for a model.

If at all possible, try to get in the habit of sleeping on your back. This allows your face to experience a bit of gravitational pull that will act as a natural facelift during those eight hours. You'll notice that you wake up looking younger, with fewer sleep lines and less puffiness under your eyes.

Excessive Sun Exposure

Sun damage may be the number one cause of premature skin aging. The sun's ultraviolet rays cause wrinkles by breaking down collagen. If you notice that your skin is tanning, that means it has already sustained some damage.

Repeated tanning causes the skin to take on a loose, leathery appearance. Some people mistakenly believe that they should tan before going on vacations so that they won't burn; the truth is that a tan offers no more protection than a Sun Protection Factor ("SPF") of 4. Sunburns cause serious damage to the barrier function of the skin, which, among other things excludes toxins, viruses, and bacteria, and helps regulate internal moisture levels.

Why anyone would willingly cause such damage just for a temporarily darker hue I will never know. But if you're unhappy with your skin color, consider a professional spray-

on tan. Not only is it easier on your looks, it's also safer. No shade of tan is worth getting cancer.

To protect your skin, apply sun screen with a SPF of at least 30 before leaving the house in the morning, and re-apply throughout the day. If you wear makeup, I recommend Eminence Organic's Mineral SPF 30, either in #0 (for alabaster skin tones) or #3 (for a bronzing effect for nearly every other skin tone) as it will not smear your foundation. If you go makeup free, at least be sure you have an SPF of 30 in your daily moisturizer.

Unhealthy Food

Sugar. Most people in our culture eat quantities of sugar far higher than our bodies evolved to tolerate. In his book The Perricone Prescription (HarperCollins 2002), Dr. Nicholas Perricone explains that blood sugar spikes when a person eats a food high in sugar, and a process called "glycation" begins. When glycation occurs, skin (as well as other organs) becomes more susceptible to signs of aging because sugar molecules are delivered directly to the skin tissue and attach themselves within the collagen matrix, causing a process similar to oxidation – thus "cooking" the skin. It's also important to note that white flour is quickly transformed into sugar by our bodies, so eating it in excess has a similar effect.

Trans-fats. In the book The Truth About Beauty (Simon & Schuster 2007), Kat James refers to trans-fats – an ingredient in many prepared and fast foods – as "a free-radical bath for your body." A free radical is a molecule that has at least one unpaired electron, and is therefore unstable and highly reactive. In bodily tissues, free radicals can damage cells, which in turn accelerates the progression of age-related skin conditions and disease. They also inhibit the cells' ability to absorb the Omega 3 fatty acids necessary for keeping inflammation at bay and regulating hormones.

Some free radicals occur naturally within the body, but trans-fats elevate these levels.

Healthy-looking skin is the result of a healthy body. Since the skin is the last organ to be supplied with nutrients, it's the first to start reacting to a nutrient deficiency. If a deficiency is present, the skin will usually make the first symptoms visible; if we don't treat this in a timely manner, we may soon begin feeling sick internally as well. The best way to address such problems over the long term is to eat a healthy diet. In Appendix 1 at the end of the book, I list some foods that will benefit your entire system, but have an especially pronounced effect on skin health.

Alcohol. Drinking alcohol is one of the most dehydrating things you can do to your body, because in its hurry to expel this poison, the body excretes water at a much greater rate than normal. This causes all the ill effects discussed in the Dehydration section above. Alcohol also causes the capillaries in the skin to dilate and sometimes break, which is why drinkers often have a ruddy complexion or many broken blood vessels under the skin.

On top of that, digestion of alcohol also gives rise to elevated levels of free radicals, which are transported to the skin via the blood. Once they arrive in the dermis, they start waging war on the two skin proteins that keep you looking young: collagen and elastin.

If you are enjoying a few cocktails, try to be fully hydrated before your first drink, and down at least 6 ounces of water after each drink as well. More than a couple of drinks twice a week can quickly wear on your appearance. Be prepared for those puffy eyes in the morning if you have more than just a couple of drinks in one night!

Insufficient Exercise
Exercising will benefit your health in a number of ways: improving muscle tone, mood, ability to sleep, and a host of other things. Most importantly for our purposes, it

also improves your circulation, and good circulation leads to more nourishing blood flow to all layers of the skin, as well as quicker removal of toxins and free radicals from the tissue before they can do damage. Exercise also creates optimal conditions for new collagen formation.

As with any new exercise program, you should consult with your doctor before starting. You should also start out with gradual increases in your activity level. Those who try to be superheroes from the start often burn out quickly.

Just add a 30-minute walk, or a 15-minute jog to your daily routine at first. After a week or two add in a few sets of squats and sit-ups. Due to the feel-good chemicals (endorphins and enkephalins) released during exercise, you should quickly begin craving your workout time. If you don't, you may be pushing yourself too hard and should consider taking it down a notch before you burn yourself out.

Skin-Inflaming Habits
Acne and other skin inflammations can wreak havoc on your appearance. As an esthetician treating acne, I've seen many cases improve by applying a couple of simple lifestyle changes. Here is a quick checklist:

- Stop using scented lotions, hairsprays, and perfumes for a while and see if the inflammation starts to clear up. These products can often cause allergic or other skin reactions. You may also try using a different shampoo, perhaps one with Tea Tree oil, which has anti-microbial properties.

- Avoid wearing hats. They can suffocate the epidermis of your forehead and keep that part of your face soaked in oil and sweat. Keep your face clean and let it breathe.

129

- Wash your pillowcases regularly. I change mine every night or at least cover it with a clean t-shirt. That might sound like overkill, but you sweat much more at night than you realize. Couple this with the skin you shed, and you're sleeping in a breeding ground for bacteria and thus skin infection.

- Remember the importance of water. I'd say adequate hydration is the fastest and easiest lifestyle change you can make to reduce acne and signs of aging on your skin.

Bad Lifestyle Choices

I'm sometimes asked whether there is really as much partying, drinking, drug abuse, casual sex, and self-indulgent living in the modeling world as is sometimes portrayed in the media. The answer is that it depends on the particular model in question. People's abilities to keep their wits about them under the highly artificial conditions associated with this profession vary widely.

Elevated levels of stress can degrade rational decision-making, and at certain moments in your career there may be the temptation to think of yourself as more than an ordinary human. The levels of attention and flattery, the income, and the pampering everyone seems eager to lavish on you can warp your perception of who you are and what you can safely do. Some are also saddled with the delusion that you need to keep up the appearance that you are highly in demand and successful even if you're not.

This loss of perspective can lead some people to abandon common sense, as if they believe that the normal laws of cause and effect no longer apply to them. One problem with being sensible in this context is that the people surrounding you may not always try to keep you from doing stupid things, because – surprise! – they don't always have your best interests at heart.

In fact, there will be fake friends and predatory men who start circling you when they see the money rolling in, as well as bullshit "managers," phony photographers, and others who pretend to be bigger, more successful, or more powerful than they are, and who will assure you that they can make you famous in exchange for money or sex. You should avoid anyone who is constantly dropping names and talking a big game with little or nothing to back it up, anyone who asks you to drop large amounts of cash (or your pants) in return for stardom, or anyone who encourages you to take drugs or drink more than you should. Your health and safety should be your number one priority, and you need to learn to make rational decisions and maintain a balanced lifestyle even in the face of temptation.

Pregnancy
Pregnancy is, of course, neither a health problem nor a poor lifestyle choice – just the opposite in fact, in my experience – but I'm including it in this chapter because it can play hell with your skin if you don't take extra precautions during the months prior to and just after the baby is born. Every model dreads stretch marks, but I had an 8-pound baby without getting a single one, and you can too.

Once you're pregnant, your best friend is Cocoa Butter. Mix it with a little water to increase absorption and apply liberally twice a day from neck to knees. Trade in your old body-wash for one containing cocoa butter. If you can afford it, get prenatal massages every 6 weeks for hydration infusion as well as maintenance of skin tissue flexibility.

Also, keep the skin tissue as internally hydrated and nutrient rich as possible. You can do this by drinking plenty of water (don't even think about soda for at least 9 months!). Plenty of vegetables, fruits and lean proteins, as well as food rich in healthy fats such as Omega 3s, will also help keep skin supple and hydrated. (If your source of Omega 3s is fish, make sure you avoid taking in too much mercury, which can cause serious damage to your baby.) You should

start this skin regimen the moment you discover you're pregnant.

Following this advice, you can hope to leave the hospital stretch mark-free with your beautiful newborn. After your child is born you will undoubtedly be exhausted and busy for a few months, but you need to keep up your skin defense program for 8 to 16 more weeks. If you're breastfeeding, switch to lanolin instead of cocoa butter on the chest area, as it is lighter in scent and nearly tasteless for the baby. Also, as soon as your doctor gives the okay, ease yourself into a moderate workout regimen to improve skin tone and circulation.

I recommend alternating between the two best preventive creams out there AFTER your baby is born. Every morning (after your shower) apply StriVectin-SD (do not use this cream while pregnant), and Fruits & Passion Cocoa Butter every night before bed.

This all sounds like a lot of trouble – and it is – but now I have a beautiful, wonderful little boy, and not a single stretch mark!

Chapter 13

Life After Modeling

There came a time in my career when I thought retirement was fast approaching. I had entered my 20's, and kept hearing otherwise sensible people sharing the conventional wisdom that "models are washed up by 22." As it turns out, those predictions have been about as spot-on as Harold Camping's Rapture prophecies.

But being young and impressionable, I obsessed over my casting-to-hired ratios, anxiously analyzed my booker's every remark, and studied my face in the mirror every morning for liver spots. The idea of retiring the year after I could legally drink alcohol gave me the cold sweats. I decided to find a way to stay in the industry, modeling or not. While it turned out that my expected retirement date was off by a decade or two, figuring out what I was going to do "afterward" was valuable, and I recommend it to those of you who are not already following a plan for your post-modeling life.

Think about what you're going to be able to offer employers after your modeling years are over. If you want a career outside the fashion/entertainment industry, make sure you're on a track that will take you there. Take courses, work part-time, or at least volunteer a few hours a week in that field.

Keep in mind that hiring a former model may not excite Human Resources managers who believe, along with the rest of the world, that the ability to smile and walk up

and down a raised platform are all the job requires. Sure, you can try to educate them about what modeling really involves, but they'll probably just think you're trying to puff up your accomplishments. I'm not suggesting that you leave your modeling experience off your resume, just that you also have job-relevant education or work experience from the same time period.

On the other hand, if you want to continue to work inside the industry, your modeling experience will give you a big advantage in entering most of the careers discussed below.

Wardrobe Stylist

These are the people you see just off set holding pieces of clothing while staring pensively at the models. The client/photographer tells the stylist what basic theme or look he wants for the shoot; it's then the stylist's job to pick out clothes that both express that concept and suit the particular model(s) being photographed. A stylist may work alone or under a fashion designer.

You can learn a lot about how stylists do what they do by simply watching them work and listening to their discussions with other members of the shoot team. They're often willing to answer a model's questions about what they do, so be sure to pick their brains (without disrupting the shoot, of course).

Obviously, a keen eye for style and fashion, and an appreciation of textiles, color, pattern, and silhouette are requirements for the job, but in my experience most models either already have these qualities or can develop them quickly.

Remember that as a freelance model, you often provide or select the wardrobe: on such shoots you are the wardrobe stylist! This is valuable on-the-job training, and you should take advantage of it. These shoots may also let you impress photographers and clients with your wardrobe

skills, giving you an advantage in booking styling work with them in the future.

Fashion Designer

Fashion designers are the people who invent the clothes the wardrobe stylist selects. They may design haute couture, ready-to-wear, or mass-market garments. Clothing manufacturers often employ them, but some go into business for themselves. Fashion design is intensely creative and fiercely competitive. It requires both artistic skill and the ability to forecast consumer tastes. The ability to use computer-assisted design (or "CAD") is a great advantage, but the ability to sketch your ideas remains an important skill as well. Excellent communications skills are also needed, because you must be able to direct a design team, as well as sell your vision to profit-driven clothing manufacturers/retailers. It's not a profession for the faint of heart or those who lack self-confidence.

Before you conclude that fashion design is too rich for your blood, however, you should know that many models have made successful transitions into the field. Christy Turlington with her Nualabrand, Elle Macpherson with her lingerie line, Erin Wasson for RVCA, and Kate Moss for Topshop, are all examples of models achieving brilliant success as fashion designers. Many little-known freelance models have also become successful designers.

If you're interested in becoming a fashion designer, it helps to get a degree from a fashion design program. You should also put together a portfolio of designs you have created. These are both projects you can pursue while you're still modeling.

Fashion Educator

A number of well-known art schools, design schools, and universities offer degrees in fashion design and related fields. If you'd like to teach in one of these, your experience as a model will surely be a plus. However, you will likely

also need a degree in fashion or a related field, so it's wise to go to school part-time during your modeling years.

Makeup Artist

After the photographer, the makeup artist ("MUA") is the team member models spend the most time with. And if you've been doing your job, once you're a successful model you'll be partway to qualifying as a professional MUA yourself. While modeling mostly calls for fashion and clean-beauty makeup, there is a broad demand for MUAs in many other fields too, including theatrical, special effects (mostly for TV and film), and bridal makeup. Most states don't require MUAs to be licensed, but many employers only hire licensed MUAs. Maybe for this reason, about half of all MUAs are self-employed.

The U.S. Bureau of Labor Statistics projects that MUA job opportunities will grow much faster than most other professions. Makeup isn't something that can be applied to American customers by low-paid workers in China or India, so these jobs are safe from outsourcing. Also, the advent of high-definition video like HDTV and BluRay means that much more attention has to be lavished on actors' faces. Because of this, the cosmetics airbrush, which can apply very uniform and subtle layers of makeup, is becoming more important. While professional airbrush systems are expensive, you should become proficient at airbrushing if at all possible.

Esthetician

Most states require estheticians to pass a licensing exam, because in addition to makeup they provide comprehensive skin care, including treatment of skin infections, signs of aging, and other skin problems. You need to complete a course of study that may run from 6 months to two years, and which covers anatomy, skin physiology,

infection control, hair removal, product chemistry, facial techniques, and certain body treatments, among other topics.

When at 22 I felt the cold hand of old age closing around me, I decided to get an esthetics license. I continued to take modeling work, but enrolled in an esthetics program. I also set up MUA portfolios on several modeling sites. Every time I stepped in as MUA on a shoot, or did makeup on a wedding party, I put the experience on my resume and added the best photos to my portfolios. Over time, I built up an extensive makeup kit, and whenever I was on-set with established MUAs, I asked as many questions as I could without getting too annoying.

Someday I probably will retire, and when I do, I have another career waiting for me in the fashion industry.

Photographer

Photographers who are ex-models have two big advantages: first, they have an almost instant rapport with their models; second, they will have spent many hours observing how experienced photographers work. If you want to be a photographer, take full advantage of this while you're still a model. Most photographers are flattered when anyone takes an interest in their art, and are usually willing to answer questions on-set about lighting, lenses, shot angles, and so on (often in greater detail than strictly necessary).

The worlds of fashion, travel, fine art, weddings, portraits, food, stock, and special-interest publications keep quality photography in high demand. The bad news is that the field is highly competitive, especially because of the hordes of serious (and sometimes skilled) hobbyists who are willing to give their services away free or cheap. Elite fashion photographers can earn very large incomes, but most photographers do not.

Because of the flood of aspiring/hobbyist photographers into the market, college courses, how-to books, online materials, and seminars on photography abound. However, few photographers have as many opportunities for on-the-job training as you do as a model.

Agency Booker or Owner

Most agency people have previously worked in some part of the fashion industry, many as models themselves. In fact, some of the most important agencies were started by ex-models, including Ford and Wilhelmina. This is no coincidence: former models have a big advantage in picking applicants with the skills and personality traits necessary for a successful career. Successful models also develop many industry contacts, with obvious benefits for agency work.

The most promising model prospects seek established agencies with good reputations, so it's usually best to start by working as an intern for one of these agencies. When it comes time for you to transition from model to agency intern, your best chance is with an agency you have worked for and have a good relationship with, but any model who has a great reputation in the industry will likely have little trouble landing work on the other side of the desk.

Casting Associate or Casting Director

Casting directors and associates are another group the experienced model will have gotten to know well. After going to numerous castings and go-sees, she will have a good idea of the process these specialists go through to pick the right face, look, and personality to represent a client's campaign or product.

Casting directors/associates may work for large commercial or fashion firms, or they may set up their own agencies. Like bookers, they often start as interns for other industry professionals; and again, former models who retain many industry contacts have an advantage.

Fashion Journalist

If you love the fashion industry and can write, this could be the job for you. Fashion journalists include writers and critics who report on or analyze industry news, trends, issues, and gossip. They may write features for newspapers, print or online magazines, websites, blogs, or for TV reports; some write books about the industry. Some journalists are employed by publications; others work as freelancers.

Fashion journalists need an in-depth knowledge of the industry, and a model's first-hand experience and contacts are, of course, big advantages. In some cases, academic credentials like a degree in journalism or sociology may help persuade employers to hire you. One route open to anyone (degree or not) is a blog on the fashion industry. Having a widely read fashion blog when you retire from modeling should greatly ease your transition into the fashion journalism field.

Actress

At this point you know that modeling often is a kind acting. A model's experience creating characters to fit each photographer's and client's concept is a significant advantage when joining the ranks of aspiring actresses. This is especially true if she has also found time to enroll in acting courses.

There's no reason to wait until you're ready to retire to start going to auditions and castings for theatrical, TV, and film productions. The skill sets in the two fields are so similar that such work can greatly benefit your modeling resume.

* * *

The lesson here is simple: to set herself up for a smooth transition and a successful career afterwards, an intelligent model will prepare a second profession in the background even as she climbs to the top of her trade.

Chapter 14

The Future of Modeling

When I started modeling a dozen years ago, no one could have foreseen how the industry would look today, and it's unlikely that anyone today can predict how it will look a dozen years in the future.

That's not going to stop me from trying, though. There are some trends suggesting how things like demand for models, working conditions, and pay will evolve in the next few years.

Technological Changes

Cameras are a major consumer product, with a dozen major companies making them and millions of people buying them. New designs come out every month, and the news is full of discoveries that will supposedly "revolutionize photography." If these reports are true, it's going to get even easier to take high-quality pictures with an affordable digital camera, which seems likely to draw even more photographers into the field. This should increase the demand for models more than ever before, making work easier to find and better paid – at least for those of us with the qualifications and drive to take advantage of the opportunities.

Another thing that could affect the modeling world is improvements in travel technology. More efficient airliners and faster trains could drastically reduce the cost of travel.

This could increase freelance work opportunities even more by making it cheaper for photographers and models to get together from across the country or the world. On the other hand, there's also a downside to these transportation improvements.

Overseas models charge far less, on average, than American models. When they make themselves available for shoots in the USA, American models lose out through plain and simple market competition. The frequency with which this occurs is likely to increase with more affordable travel. European photographers and clients have already become far too accustomed to getting something for nothing. Unless models – both American and foreign – start to protect their economic self-interest by demanding the pay they deserve, this trend will continue to drive down the market value of freelance models across the board.

Industry Changes

Some industry changes seem long overdue – which makes me think they will finally occur in the next few years.

First is the formation of a national Models' Guild. To be honest, I can't figure out why a Model's Guild wasn't formed long ago. With the modeling market becoming so muddied by scammers and oversaturated with posers, now would be a perfect time.

Because federal law doesn't give collective bargaining rights to "independent contractors," models probably cannot form an actual union, with the power to strike, set wages, and so on. But there are many other worthwhile things a Models' Guild could do, such as:

- Distributing alerts identifying scams and photographers/clients known to be abusive;
- Setting membership requirements and codes of conduct so that clients can rely on Guild models to meet certain standards;

- Setting non-binding rate guidelines for models at various levels;
- Incorporating a system that allows models to rise to higher levels based on credentials;
- Establishing legal and medical funds;
- Maintaining legal counsel for models who have legal questions.

A Models' Guild would go a long way towards the prevention of dangerous working conditions and under-compensation.

I can tolerate models who just want to play dress-up, and I respect models who only care about creating art; but there should be an organization for those of us who are trying to earn a living at this.

The second overdue change involves the modeling agencies. Given the smart, savvy people who run them, it has been a surprise to me how poorly the agencies have adapted to the industry developments of the last decade. In fact, the changes they have made often seem to do more harm than good.

It should be clear to the agencies by now that padding their boards with more models than they can manage, and throwing hordes of girls at every casting is leading to their demise. I'm hoping they will return to the business model that made them so successful in the first place: assuring clients that the models under their representation were of the highest quality, and that the clients' casting requirements would be zealously observed. The agencies still have many great models today, but they are often sunk in seas of mediocrity that no client wants to swim through – especially now that they don't have to.

Equally mysterious is why the top agencies haven't jumped on the new genres and niches that have begun to take up more and more of the modeling market. Alt fashion is an enormous market; glamour models are always in

demand; plus-size and petite models are in increasing demand. But most of the major agencies have scarcely any models in these categories.

Modeling agencies are part of the fashion industry, which, by definition, is in the business of informing the public of changing trends. One of these trends is an evolving social attitude toward nude art. I'm not talking here about pornography or trashy glamour, but about high fashion nudes and artistic figure nudes. The senseless ban most American modeling agencies still have against their models posing nude seems to be yet another means of business suicide.

Nearly every one of today's (of-age) supermodels has posed for an art nude shoot or appeared topless in a European high fashion magazine; no harm has been done to their reputations or the reputations of the clients who hire them. I myself almost lost an agency contract once because they got their hands on a topless fashion shot of me. (They backed off only when I informed them that the photo was being considered for Vogue España.) Agencies don't require their models to wear only 1940's fashions; why should they force them to adopt 1940's attitudes toward nudity?

It would also serve the agencies to find some way to tap into the enormous market of aspiring and hobbyist photographers. While these people have less money to spend per model-hour than commercial and fashion clients, there are many times more of them. At present, virtually all of this business is in the hands of freelance "Internet models."

It seems to me that it can't be long until our mainstream agencies either wise up or die. I'm hoping that the current sad state of agency representation is only temporary, and that reform will restore it to its former glory.

In The End

Despite many problems, I believe the modeling industry will be heading in a positive direction in the next decade. Expansion of markets due to technological improvements in cameras and transportation will be only partly challenged by competition from underpriced models. Improvements in cosmetics and anti-aging treatments should allow skilled models to have longer careers, and changes in public attitudes toward beauty should continue to open the modeling market to a wider variety of people. Agencies are likely to finally catch up with the industry changes and become as attractive a career avenue as freelancing. Best of all, a Models' Guild may finally be formed, allowing many kinds of mutual assistance, professional education, and the rooting out of abuses and unnecessary complications.

However the industry evolves, though, the skilled, informed, dedicated, and hardworking model will always be in demand.

Glossary

Accessories
Complements to the wardrobe, such as hats, jewelry, hairbands, belts, and handbags.

Advance
A loan that an agency may give to a member of it's model board. The advance will be taken out of payments for future work.

AFTRA
The American Federation of Television and Radio Artists (AFTRA) is a national organization for models working in entertainment and media. AFTRA represents model in broadcasting such as for radio commercials, news and sports, TV sitcoms, soaps, children's programs, talk shows, and reality TV.

Age Range
The age a model can successfully pass for. My age range at the time of this writing, for example, is 20-28.

Agency Fee
Percentage of the model's earnings that an agency takes for services rendered.

Agent/Agency
The middleman who works on the talent's behalf to land bookings with clients. Agents are also in charge of handling aspects of the talent's career development.

Appointment Book
Schedule ledger used to record bookings, auditions, and castings.

Art Director
The creative force behind the look / feel of a shoot.

Assignment
A project that a model is hired for, also known as: job or gig. Can be an ad, editorial spread, commercial, runway or trade show, etc.

Audition
Like a try-out for work on video. The model meets with the casting director for a chance to prove that he / she is worth hiring for the assignment.

Availability
Your ability to be booked on certain dates.

B

Beauty Shots
Photos whose main focus is the face and hair. Used mostly in jewelry and makeup advertisements. A makeup-free or low-makeup version of these shots (often called a headshot) are important in a model's book, as they show off his / her unadorned beauty.

Book
(n) A model's portfolio. (v) To assign a project.

Booking
When you are hired for a project.

Booking Agent (Booker)
Agent; an agency employee whose job it is to get jobs for the agency's models.

Booking conditions
Agency's stipulations for the client and the model regarding working conditions and payment.

Book out
Informing your agency that you are unavailable and therefore not to submit you for castings / jobs during a certain time period.

Breakdown
The comprehensive details of a project that inform everyone on set of what the casting director is looking for in the finished product.

Buy-out
Advance payment from a client for future use of works featuring the model, for a specific period of time.

C

Call-back
When you are asked to come in for a second meeting (after the initial casting call) by the client.

Call sheet
A sheet providing information that the model will need for a job, such as duration, location, theme, etc.

Call time
The scheduled arrival time of models and other team members to a production.

Casting call
A meeting with the potential client and/or casting directors to see if you are a good fit for their project.

Casting Director
A person hired by a client to select model(s) for their project.

Cattle call
A casting call in which there have been minimal guidelines / requirements set for the models. Because of this, the number of hopefuls at such castings can reach into the hundreds or even thousands.

Character Look
Models that have an interesting or unique look that will bring attention to an ad. Usually, a gig that calls for such a look is seeking more of a quirky face as opposed to traditional beauty.

Checking In
Contacting your booker to see if you fit the requirements for any of the castings the agency has that day.

Client
Whoever is in need of the model's services, and therefore also pays for the production and modeling fees.

Cold Read
When the model/actress is not allowed to view the script prior to performing it for his/her audition.

Commercial Look
A look that appeals to the mass of consumers. Jobs that call for a commercial look are usually looking for models with more traditional appeal.

Commercial Print
Ads with an everyday type casual appeal that sell products.

Commissions
A percentage of the profit total, often taken by agents/managers.

Composite Card (Comp Card)
A card used by models for promotional purposes. Usually the front of the card features a headshot and the back contains 3-6 other photos, contact information, and measurements.

Contract
A binding agreement between two or more parties that explains the terms and conditions expected of each party for the duration of their professional relationship.

Cosplay
A performance art where participants dress up, often in very elaborate costumes, as superheroes or anime characters.

D

Day Rate
The amount agreed to be paid to the model in order to have them reserved for the full day. This rate is expected to be paid in full regardless of how many hours of that day the model actually spends working.

Designer
One who creates things (in the modeling industry, usually clothes or sets) out of his or her own vision.

Direct Booking
A booking made without a casting call or go-see. Typically these are from an outside market, normally including airfare, accommodations, and expenses during the shoot dates.

Director
The professional who supervises the production or shoot. He/she makes artistic decisions, and is also in charge of keeping the production on schedule.

Dressers
Model helpers who assist in the speedy wardrobe changes backstage at fashion shows.

E

Editorial
Typically, 4-8 pages of fashion photos with no/very little text. Sometimes called fashion stories, they may or may not be intended to sell specific items; their main purpose is to inform the public of new trends or help a publication earn credibility.

Escort
A person who accompanies a model to her shoot or other work related event, supposedly for protection Note: A model who insists on bringing an escort comes across as inexperienced and may be considered unprofessional, unless of course she is under 18.

Exclusive
When you cannot work with another agency in a specific market because you are under contract with one already.

Expenses
Overhead (such as the cost of marketing materials and travel) necessary for successfully obtaining work.

F

Fashion Model
Model who meets the specific industry requirements of being preferably 5' 9"+ and thin, with unique facial features. Fashion models walk in fashion shows, and pose for campaigns and editorials in magazines.

Fashion Show
A live fashion presentation in which models walk in designer garments.

Feature
A headlining magazine article.

Fee
The pay expected from the client for your services.

First Option
The model that is the best fit for the project, in the client's eyes, after a casting, becomes "first option." Until their entire team is fully ready to commit, they will call the agency and put a first option (or hold) on you for a specific date. Your agency will then reserve that date for them and you will be expected to leave that date available unless and until the client releases you.

Fit Model
A model of standard proportions who fits the designer's clothes perfectly, and therefore is used as a template for the rest of the collection.

Fitting
Where a model is required to try on garments prior to a show or a shoot. This is done far enough in advance that alterations can be performed before the event.

Flake
An unreliable person who fails to attend a scheduled shoot or event she has agreed to, and doesn't bother to give the other team members sufficient notice.

G

Garment District (also known as The Fashion District)
The part of a city, in a major market, where a lot of clothing manufacturers have their businesses.

Glossy
The shiny finish applied to a photograph (most commonly head shots).

Go-see
A meeting with a client that may not be for a specific job, but is more an opportunity for the client to see if you might be the inspiration for their next campaign.

H

Hair and makeup ready
The client is not providing hair and makeup artists, so you are expected to show up to the shoot with these tasks already finished.

Hold
When a client/casting director is interested in booking you for the job, but not entirely ready to commit. In this case, you will be told to reserve certain dates for the assignment even though you may not end up booking the job in the end.

High Fashion
Refers to the up-to-date fashion trends of the moment.

I

Invoice
An itemized bill for services provided that is issued to photographers/clients who have not yet paid your fee fully.

L

Look Book
Booklet showing a designer's new season of clothes.

M

Major Markets
These are heavily populated cities that have the most industry action. In America, the major markets are New York, Chicago, LA, and Miami. In Europe, they are London, Paris, and Milan.

Makeup Artist
This is a professional who applies makeup to models, actors, or public figures before they appear in front of a lens or the media.

Market Week
The 4-6 times a year when seasonal clothing lines are shown to buyers.

Modeling Agency
A company that consists of bookers who connect clients with models and vice versa.

Model release
A document signed by an agency (or directly by the model) that grants the client permission to use photos of the model to promote their product or business.

Monologue
A prepared piece to be read to casting directors at an audition.

N

Non-union
Talent without union membership, who must obtain waivers in order to work on union projects.

O

On Location
Any place or area where a shoot takes place outside of a studio.

Open Call
When agencies open their doors to meet with aspiring models for possible representation.

P

Parts Model
One who works in a commercial modeling capacity but only has a specific body part photographed. Parts models can be hand models, hair models, leg models, etc.

Petite Model
A model that is less than a size 6 and shorter than 5'6".

Per Diem
Latin for "per day," the daily expense money a production gives you for food, travel, etc. when you are shooting on location for an extended period of time.

Plus Size Model
A model who is at least a size 8, but more typically a size 10 or above.

Portfolio
A model's book of the best of her previous work that represents her photographic range and experience; may also refer to an online presentation with a similar function.

Print Work
Photography taken for printed material such as mail order catalogs, books, brochures, magazine covers, and advertisements.

Producer and/or Production Coordinator
One who organizes all the necessary elements of a project, such as scoping out and choosing the location, hiring the talent and staff, etc.

Promotional Modeling
Modeling gigs that require models to hand out information about a service or demonstrate products. These jobs occur

mostly at live events such as product launches and trade shows; also known as "spokesmodeling."

Pose
The deliberate positioning of the model's body in front of the camera.

Print Model
A model who is photographed regularly for product advertisements and marketing materials that will be printed in catalogs, magazines, and other media.

Proofs
Shots that have not yet been altered by retouching.

R

Rate
The agreed amount of compensation.

Release
When a client tells your agent that you are free to book work on dates that were previously being held for the client's project

Reshoot
When a second shoot is requested because the client was not happy with the results of the first shoot

Residuals
An additional fee that is paid to the model and his/her agency each time a commercial the model appears in is aired (this practice is less common today).

Runway (Catwalk)
A platform models walk on to present a designer's line of fashion.

SAG (The Screen Actors Guild)
A labor union in the entertainment industry that was founded to protect talent in film and TV.

Sample
This is the original garment made by a designer, which is then replicated to produce ready-to-wear or mass-market clothes.

Sample Size
The specific size a designer makes his/her sample garments.

Script (also called Sides)
The dialog that is spoken in video work.

Showroom
A room in which a designer shows corporate buyers his latest collection of clothing or fashions.

Showroom modeling
Showroom models present a clothing line for potential buyers in a showroom setting. They may be required to have an enchanting and outgoing personality and an ability to persuade the buyers to purchase the line or they may just be asked to pose and walk in the clothes and leave the selling up to the designer.

Sides
Scene(s) from a script to perform at an audition.

Spec shot
A conceptual shot that is taken by a photographer on his own initiative in hopes of selling it or a concept based on it to a client.

Spokesmodeling
Modeling that requires you to speak publicly on behalf of a particular client or their products/services.

Spread
This can be a photo layout that covers two pages of a magazine, booklet or portfolio. It can also refer to a photograph, usually pornographic, of a female exposing her genitalia.

Stats (Statistics)
Model measurements that include: height, weight, body dimensions, hair/eye color and clothing/shoe sizes.

Stylist
One who finds ways to complement the garments on a shoot by coordinating and/or accessorizing them.

Swimsuit ready
Hairless legs, bikini area, and armpits.

T

Tear Sheet (Tearsheet)
A published advertisement in which you appeared. After publication, you should cut the page from the magazine and insert it into your portfolio.

Test shoot / free test
Usually an unpaid shoot involving a full team. The intended purpose is that everyone involved gets new and improved images for their respective portfolios, although it is understood that the end results may not be at the highest level (hence the term 'Test'). An agency will often line up a test shoot with a model to see how she performs prior to signing her.

Trade (TF or TFP)
Similar to a test shoot, though there is not always a full team. The term is used more in the Internet modeling world.

Trade Show
Industry promotional display of products/services that usually takes place in a hotel or convention center.

Trunk Show
A traveling fashion show that's usually low budget and, therefore, held in stores as opposed to large convention centers or famous nightclubs.

Typecasting
Being cast for a part in a film or commercial due to your look or your previous success with similar roles.

U

Union
An organization that charges its members fees in exchange for collective representation vis-à-vis management, and sets standards for what its members can/cannot do in accordance with certain terms and conditions.

Usage
The specific rights a client has to use photos of the model. This agreement should cover any monetary stipulations required for client usage in different markets, publications, and time periods.

V

Voucher
A document that records the job details and is filled out by the model at the completion of an assignment.

W

Wardrobe
A collection of garments on set that is intended for use during the shoot.

Z

Zed Card
See Composite Card.

Appendix 1

Superfoods for Skin Health

The foods listed below are especially good for your skin, but most of them have important benefits for general health as well.

Blueberries and Blackberries. Both of these berries are extremely high in anthocyanins (antioxidants also responsible for their deep coloring). These protective antioxidants destroy free radicals, and are responsible for the maintenance and support of skin's vital structures. These berries also contain vitamin E, which works to keep skin protected against wrinkles.

Almonds. The glycosides and vitamin E in almonds work in synergy to defend your looks against aging. Almonds also give you a good dose of Omega 3 fatty acids, which halt inflammation before it progresses into skin wrinkling.

Fish. Many fish are high in Omega 3 acids, which are some of the best inflammation fighters known to science. Inside our bodies, the EPA Omega 3's convert into resolvins, potent inflammation fighting chemicals. Reducing wrinkle formation by decreasing inflammation levels is only one of the health benefits of fish. Most fish also contain vitamin B6, Selenium, and Niacin, all of which support quick cell

turnover within skin tissue, ensuring a fresher, more youthful appearance.

Garlic. Garlic contains compounds that fight inflammatory and wrinkle-causing enzymes. Just be sure to have extra breath mints in your bag!

Carrots. The beta-carotene (that orange stuff) in carrots converts to vitamin A in the human body. Because vitamin A has proved to be such an amazing defense against wrinkles, it is now the most commonly used vitamin in topical wrinkle creams.

Celery. Celery contains silicates and potassium, two nutrients that help tone and firm the skin, as well as vitamin C. Silicates also strengthen the proteins in skin, hair and nails. If you become deficient in silicates, you will notice itchy dryness and loss of skin elasticity, which can also result in facial sagging.

Rhubarb. Like celery, rhubarb is high in silicates.

Soybeans. Soy has been shown in studies to increase collagen production in cells. This collagen boost is due to the high isoflavin content, which leaves skin youthful and firm.

Brazil nuts. These fortify you with selenium, vitamin E, magnesium, and thiamin, all nutrients important to skin health, and extremely effective against free radicals.

Mangoes. High in magnaferin and lactase, Mangos help us digest other important nutrients. They also offer an abundance of vitamins A and C, which will keep free radicals from deconstructing your youthful look. Like celery and rhubarb, this fruit is also high in silicates.

Avocado. Polyunsaturated and monounsaturated fats, as well as elution, help to control the skin's moisture levels. Avocados contain large amounts of all three. Adding avocados to other healthy dishes has also been shown in studies to increase the body's absorption of other skin-healthy nutrients such as caretinoids.

Watermelon. Watermelon is a great source of lycopene, which prevents damage to the skin's moisture barrier by tightening the junctions between our skin layers. Watermelon also generates a lot of energy within the skin by way of the B vitamins, which helps maintain the health of the moisture barrier.

Kelp. The lipids in kelp are extremely useful to the skin's hydration. Not only do they reinforce the moisture barrier, they also prevent oxidation of the moisture-rich fats in the skin. High in vitamin E and vitamin C, kelp is very effective in discouraging skin dryness.

Pumpkin. You get over 400% of your recommended daily allowance of beta-carotene in one cup of canned pumpkin. This beta-carotene is used by your skin not only to ward off wrinkles but also to stay hydrated and glowing.

Green Tea. The unbalanced little muggers called free radicals are on a mission to rob our healthy cells of electrons. If they succeed, we're left with dead cells that show up as wrinkles, dullness, dry skin, eczema, acne, cold sores, and hyper-pigmentation, as well as other, more serious threats to our health. So how do we fend off these molecular felons? By keeping our antioxidant levels high. Antioxidants kill free radicals with kindness, giving them the electrons they are so desperately craving, and sending them back into society as rehabilitated little model molecule citizens.

Since green tea is one of the most antioxidant-rich drinks on the planet, it pays to send a lot of it down the

chute where it can do its wonders. Epigallocatechin-3-gallate (the active ingredient in green tea) is a ridiculous word, so we'll use its abbreviation, EGCG. EGCG is getting a lot of attention today due to its unmatched abilities to protect us from the oxidative damage caused by free radicals. Not only does EGCG slow the process of aging, new findings suggest that it can actually reverse damage already done by free radicals.

Knowing all this, who wouldn't make green tea – hot or iced or mixed with other beverages – their drink of choice? (Decaffeinated green tea is available for you caffeine-sensitive people out there.) But just in case you have a love affair with your crow's feet, there are yet other benefits to your appearance associated with this awesome compound. For example, EGCG is believed to increase your metabolism, which in turn helps you burn fat faster and more efficiently.

In order to absorb as much EGCG from your tea as possible, be sure to mix in a bit of lemon juice. The citrus will lower the PH in the small intestine, increasing the levels of antioxidants that get absorbed.

Appendix 2

Agency Representation

Agency Flashback, Circa 2001

Warm surf washed gently around my feet as I sauntered down the quiet beach. I could feel my body relaxing, tension that I hadn't even known I was carrying flowing out of me. Last night my feet had been fastened into torture devices they had told me were shoes, and I had been blinded by glaring lights, but now I was relaxing as evening fell over Miami Beach's Millionaire's Row. Just a couple of months ago I had been a poor high school girl living in a sad suburb of Chicago; now they dressed me in clothes worth thousands of dollars and paid me impossible amounts of money just to walk in them. For the last few nights I had been pursuing this occupation at New York Fashion Week. Tonight –

"Christie!" a distant, urgent voice broke in on my reverie. "Come on! It's almost time!"

A male model was jogging across the sand toward me. He grabbed my hand and we ran back up the beach, my mood shifting in an instant from relaxed to borderline frantic. There was a major production setting up inside the luxury hotel we were running toward, of which I was to be one of the stars.

My career had taken off like lightning striking. By now I had done several music videos, a national commercial,

New York Fashion Week, and had been chatted up by celebrities and industry heavyweights. But I was still terribly nervous about putting on the skimpy swimwear we were showing that night and strutting it on the runway. It takes years of experience and a lot of confidence to feel comfortable in the spotlight. I was building up the experience fast, but the confidence wasn't coming so easily.

From the tranquil evening, my friend and I entered a scene of barely controlled chaos. Backstage was crowded with makeup and hair people brandishing combs, spray cans, and airbrushes, racks of clothes with wardrobe assistants running back and forth, models in various stages of undress, journalists snapping pictures, stage managers waving their hands in panic, and swarms of other people whose job seemed to be just getting in the way. We pushed through the mob and were grabbed and separated by the teams of artists who were in charge of making us beautiful.

Encouraged by some kind words from the swimwear designer, I tried to keep my nerves under control. I had been chosen to both open and close the show, with four walks in all. Four chances to trip and fall, sneeze or stumble, have my bikini top fall off, or have my career ruined in one of a hundred other ways. I'll be fine, I assured myself, trying to maintain consciousness as the lights dimmed and the music changed from classical to upbeat techno.

At a nod from the stage manager, I stepped out onto the runway and started taking long strides in time to the music. I hoped I looked relaxed and confident; on the inside I felt hyper-aware and detached, as if I was watching myself from the audience. I was relieved to see that the lighting had been arranged so that I could only see a few people in the front row at any one time. On the other side of the coin, some of the faces I did see were recognizable from TV shows and the nightly news.

In the end everything went off without a hitch. As I stepped behind the curtain after my last walk, and the

audience erupted in applause, I felt like fainting all over again – this time with relief.

As a perk, each of the models was allowed to pick out a swimsuit after the show. I chose a metallic black number that seemed likely to stay on, and took the elevator to the rooftop pool for the after-party. Upon entering, I ran into a local agency honcho who had turned me down two months earlier because "he just couldn't see a curveless plain Jane working much in Miami." It was a pleasure to introduce him to my new booker, who promptly exclaimed, "Isn't Christie great?! Clients just can't seem to get enough of her!"

At that moment I felt a tap on my shoulder, and turned to find myself face to face with Ricky Martin. He reminded me that we had met at a previous event (as if I could forget), and asked if my booker and I could join him at his table to go over an upcoming project.

Some days everything just seems to go right.

Agency Flashback, Circa 2010

Imagine a vast tar pit covered with concrete and crammed with cars and egos to the point where nobody can move, and you'll have a pretty good idea of Los Angeles. All very well if you have a helicopter or can stay home, but hell otherwise. It was in this infernal paradise that my booker one morning assigned me five go-sees at widely separated points in the city.

Because of the prevailing traffic jams, I knew I wouldn't be able to make them all, especially given the cast of thousands of other models I would likely have to battle at each. I called my booker and asked which assignments I matched the casting requirements for best, so I could make those my priorities.

"Just try to make it to all of them," she suggested brightly.

I decided to pick the three closest to each other and hope for the best.

The first of the three was for a video-game developer. It was held in the back lot of some film studio, and the models had to wait outside, in the kind of LA heat that melts a girl's face and morale. I had broiled on both sides for half an hour before the harried gentleman running the casting came over and informed me that they were looking specifically for tanned, blonde-bombshell types with curves like Marilyn Monroe. A pale, stick-figure brunette like me was more likely to get hit by a meteorite than get this job.

I apologized on behalf of my agency, gave him my comp card for future consideration, and tried not to let him hear my teeth grinding. As I turned to go, I heard him ask a colleague: "Why don't we just post our castings online? At least the models would know if they fit the requirements before they bothered coming out."

I bolted to the next go-see on my list. I could feel myself relaxing as I pulled into the parking lot; I'd been to this venue before, a big, modern loft, quiet, elegant, and air-conditioned. At least I would have a chance to chill out, even if the casting was another bust.

Entering the loft, I revised my thinking. What had been wide-open spaces was now crammed with chairs and crowded with models. As was the fashion in LA that year, some of the models had brought tiny "purse dogs," many decked out in outfits more expensive than mine. Some carried their dogs in designer handbags, others in baby strollers.

After a restful 45 minutes listening to the yapping of small dogs, I was finally called to the inner sanctum – and suddenly things seemed to be looking up.

"Your look is perfect for this!" some sort of casting assistant exclaimed as I entered. A group of people sat around a very elegant lady who seemed to be the head honcho. I saw her eyes light up as I approached, and she jumped to her feet.

At that moment classical music blared, and the lady began belting out French words and phrases, which, after a moment of confusion, I realized were directed at me. I stood there, at a loss, until an assistant abruptly stopped the music and the French lady said impatiently: "Why aren't you following my commands? Dance!"

I explained that I had no idea what her "commands" meant.

"Oh, no, no, my dear!" said the French lady. "We are looking for someone highly experienced in the ballet!"

My booker, of course, was fully aware that I had never had a ballet lesson in my life.

Another handsome apology, another graceful acceptance, another comp card left, and commiseration all around at the sad state of agency inefficiency, and the skinny brunette who couldn't dance was risking life and limb running to her car in 5-inch heels, muttering profanities that would have drawn a reproachful look from a muleskinner.

I checked the time, noted that the local traffic seemed to be moving at speeds of up to five miles an hour, and decided to try to make it to the third go-see. After waiting five minutes for some non-LA native to let me into the solid stream of traffic, I put a call in to my booker. I tried to suppress my annoyance and express myself calmly, as a lady must. I asked her what the requirements were for the job I was trying to make it to. I can't swear she was chewing gum and filing her nails, but her response was:

"What does it matter? If you can make it in time, go see about it."

Clamping my teeth shut against the storm of suggestions for her that I felt rising inside me, I hung up and drove.

I arrived at the location a full 5 minutes before closing. A note on the door said "Talent, go around back." My toes took one look at the length of the building and begged for mercy, but ignoring them, I put in some more

high-heeled sprinting, finally turning into an alley in which a door was propped open. I stopped short next to a burst garbage bag and tried to transform myself from an out-of-breath job seeker to an elegant woman-about-town, then strolled in casually. The only person around was a tired-looking man packing up the comp cards he had collected that day.

Indicating the pile of about 60 cards, I asked, "Anything good in there?"

"Size two brunettes," the man said. "Size two brunettes I want, and what do they send me? A bunch of blondes with breast implants."

"I just happen to have with me," I said carefully, "the book of a size two brunette. If it's not too late, would you like to see it?"

He flipped through my book for about 90 seconds, then wrote HIRED on my comp card, added it to his pile, and gave me a tired smile. Persistence does pay off sometimes, but that day the last of my patience for the sadly decaying state of modern-day agency representation finally ran out.

* * *

I don't want to give you the wrong idea. I started off as an agency model when I was 18, and was represented by houses like Irene-Marie and Elite under exclusive and non-exclusive contracts for ten years. My agencies did a lot for me during those early years, mentoring me, getting me valuable exposure, and connecting me with top-notch photographers. I'm very grateful for the help and opportunities they gave me, and I do think that agency representation still makes sense under certain circumstances today.

But for me to push the agency route because it was good to me once upon a time would be like telling you, in this age of automobiles, where to get the best hay for your carriage horses. For most models – and especially models

172

just starting out – agency representation no longer offers the benefits it once did. I finished off my last agency contract two years ago, and it's not because I prefer to get worse work and make less money; rather, it's because I've seen first-hand the deterioration of the agencies, and where they seem to be heading.

The Agency Route - Downsides

Even at its best ten years ago, agency representation was demanding. As an agency model, you have to be available day in and day out on short notice for castings and go-sees. If you can't be available on a certain day, you need to "book out," or request the day off – and the agency usually wants plenty of advance notice. They may also want to know why you're taking the time off. If they feel that your reasons aren't good enough, or that you book out too often, you may soon find yourself on the chopping block.

Your agency will also want to have a good deal of control over your public image. This often leads to them "suggesting" (that is, requiring) that you change or hide important aspects of your personal life. For example, a lesbian friend of mine brought her girlfriend to Chicago Fashion Week one year, and some paparazzi managed to get a picture of them kissing. For this she was hauled in by her booker and "asked to consider" pretending to be heterosexual "for the good of her career." The following week she announced that she had left her agency. I myself was once asked not to be seen with my son in parts of town where a lot of castings and go-sees take place; my agency feared that the casting directors would conclude I was older than advertised if I was seen with walking, talking offspring. Your agency is likely to try to limit the kinds of modeling work you take, even if your representation is non-exclusive. Nudity, fetish, or anything depicting illegal activity can get you fired, but even political or other "controversial" work is generally frowned upon.

All this might not be so bad if the people trying to control your professional life and parts of your private life were fully focused on your career and wellbeing. Unfortunately, your agency handlers today will likely be too swamped with other girls to be able to give your career much individual attention. As a result, their demands may not fit well with your personality or goals. This is a major reason why some models (like myself) leave the agencies in favor of self-representation. You may not have access to the most lucrative campaign castings when you're on your own, but as a beginning model you probably wouldn't have access to them anyway, even if you were with an agency.

There are other, less obvious downsides. The life of a successful agency model may sound like a fairytale, but not everyone flourishes in this pressure-cooker environment. You need to love being the center of attention, but you also need to be able to handle it when the attention wanes, as it always does from time to time – and sometimes permanently. Public access to your private life, the secret "admirers" (some of whom will scare the daylights out of you), and the media become bothersome even to the most attention-hungry, but you need to be able to handle all this gracefully.

You have to not only keep up with a hectic schedule that doesn't promise you anything in return, but also act like it's no sweat at all. You must be able to push yourself hard to succeed, but not so hard that you collapse. Finally, while cutthroat competition can exist in any occupation, the level of jealousy and backstabbing among agency models can sometimes rise to absurd levels. For example, during a casting in Miami circa 2002, one model pretended to be a casting agency associate and directed the rest of us to leave our books with her while we went upstairs to meet the client. We returned to find that she had made off with the books of all the models with looks similar to hers (i.e., her

competition in town). I was one of the unlucky saps, and to this day am unable to find copies of some of the tearsheets she took.

So being an agency model has always been challenging. But while these challenges have grown with time, the benefits counterbalancing them have shrunk. Ten years ago, agencies seemed to try much harder to respect their clients' casting requirements. Models sent to open calls or castings were picked carefully so that their looks and skills matched the client's requests. Because of this, the groups of models attending were much smaller than they are today. In those days, I'd be among between five and 30 girls who looked very much like me, all relatively close in age, size, and complexion. Fewer applicants meant that castings took less time, and a model was easily able to fit in several per day. It also meant that you were more likely to get work on the castings you were sent to, because you had already been pre-selected as more or less what the client was looking for. Because of the recent agency trend toward sending all available models to every casting regardless of requirements, today a single casting can take all day, as you wait in line behind sometimes hundreds of hopefuls.

It seems odd that agencies are so willing to waste not only their models' time, but their clients' as well. I suppose they do it out of desperation: direct hiring of models through the Internet has cut their business down to the point where they throw everything they've got at every job. While this may help them in the very short term, in the longer term it can only discourage clients further from using them, effectively driving them to hire through the Internet even more. It's one of those downward spirals you hear about, which often end with a loud noise and a cloud of smoke.

The two stories I told at the beginning of this Appendix sum up my experience with agencies as they were ten years ago versus how they are today. Other models may

have different perspectives. But I believe that as market pressures from the freelance sector have grown, many agencies have changed in ways that make them a bad deal for most models. These include part-timers and just-for-funners, and those who model primarily for artistic reasons. Those looking for a creative outlet may find the showing of clothes and products – and the prohibition from doing "edgy" work – too restrictive. Those who want to do nudes or fetish work will also likely find agencies unfriendly.

New models are not likely to benefit from agency representation either. If you take agency representation as a beginner, you'll likely be one of the least experienced girls your agency has. Who do you think they're going to send to the Old Navy casting if they're under strict orders to send only a few girls? They're going to send their most experienced pros, and that's not you.

The Agency Route - Upsides

Being an agency model does have some benefits: a good agency will find you castings and go-sees (with the caveats noted previously), negotiate pay and travel expenses for you, send you a call sheet with the details of your gig (time, date, location, team member names, and any other specific requirements). If you have a hard time making decisions, an agency can be helpful: they will choose photographers for you to shoot with when your book needs updating, and will organize your book and choose which images will go on your comp cards (though this is likely to come with fees). When you travel, you'll usually be put up at nicer places. There are also more material perks: free designer clothes, shoes, and accessories thrown in by the clients, for example. Due to the publicity and name recognition advantages agency models receive, you'll also probably have a leg up on freelance models if you want to remain in the industry after you retire from modeling (as a booker, casting director, and so on).

Qualifications To Be an Agency Model

As I've said, there is no particular "look" you need to be a successful freelance model. This is less true for agency models, because the agencies still deal mostly with "traditional" clients (fashion and commercial), and are still staffed with more conservative people (who learned the business back when the modeling industry was narrower than it is today).

Though recently I've noticed agencies taking on more girls who don't fit the strict traditional "agency look," agencies still favor girls who are taller than average, at least 5'8, with a strong preference for 5'9 or above. Being rail skinny is not so much a requirement anymore, though it doesn't hurt. The focus is mainly on a physically fit and proportionate figure that is thinner than average at least in the midsection. If you meet these criteria, most of the other requirements have to do with your skin: large tattoos, visible stretch marks, acne scars, or a "leathery" skin texture will all hurt your chances. You should also have relatively good teeth. Bonus points are awarded if you can walk gracefully in the world's most uncomfortable shoes, balancing a twenty pound headpiece (which also blocks your view), while making the most hideous and awkward contraption of a garment look beautiful and practical.

On a positive note, the "age barrier" is no longer as solid as it once was, and it isn't necessarily a deal-breaker if you're old enough to legally drink alcohol. It's definitely harder to land a contract in the fashion division of a top agency if you're in your twilight years (i.e., older than your mid 20's), but it can be done.

However, agencies have not become more flexible as to the quality of your looks. If they start to deteriorate, because of age or anything else, you may anticipate being put out to pasture. Fortunately, most women can keep their looks up for many years if they eat well, stay physically fit, and stick to a good skin care regimen. It's the models who

miss sleep with late partying and indulge in toxic substances who need to worry most about aging, not to mention waning energy and motivation. Also, a model who is known for an excessively wild nightlife will often be first to go when her agency is scaling back.

Landing Agency Representation

So how do you go about getting agency representation if you decide you want it? Agencies typically hold open calls one to four times a month, and you should plan to go to one of these. You can submit pictures to most agencies online, but unless you're an unbelievable goddess or already have an impressive resume, you're unlikely to get hired this way; even if they notice you, they'll most likely ask you to come to their next open call anyhow.

Most agencies will tell you on their websites that you should come to an open call in casual, form-fitting clothes and little or no makeup. A snug t-shirt and a pair of form-fitting jeans are usually best. A nice pair of heels is a good way to add a bit of glamour without looking like you're trying too hard. Your makeup should be minimal if you must wear any at all, and should certainly not include more than the following:

- Concealer, to problem areas only
- Clear mascara for dark lashes, brown for light lashes
- Brow powder slightly lighter than your brow hairs
- Lightly tinted lip-gloss
- Matte powder if you're oily; use blotting papers instead if possible

That's it. No eyeliner, no eye-shadow, no thick foundation, no bright lipstick or lip-liner. This will help you appear fresh-faced and young, and will also show the bookers that you have nothing to hide.

Bring along a set of snapshots to leave with the agency that show you with minimal/no makeup, preferably in a solid-colored two-piece bathing suit. The set should include:

- A straight-on headshot with no smile
- A straight-on headshot with a smile
- A profile headshot with no smile
- A straight-on three-quarter length shot
- A straight-on full length shot
- A full length profile
- A full length shot of the rear view

On the back of these snapshots write your contact information and your measurements (height, weight, chest/waist/hips, dress size, and shoe size). If you have comp cards or a book of professional photos, you should bring those as well, but they aren't required.

Arrive no more than 15 minutes early and not a minute late. Keep your attitude professional. In addition to wowing them with your looks, you're trying to show them that you're easy to work with and eager to learn. Be confident but not cocky, enthusiastic but not manic, serious but not demanding. Follow directions to the letter. Smile and make eye contact. Remember to take note of and use the interviewer's name when you speak to him or her.

You should also be prepared to answer some questions about your experience, your age, and your work ethic. No matter what your answers are, give them with confidence and a bit of personality.

Confidence is most visible through body language and free-flowing conversation. This means no slouching, no biting your lip, no fidgeting with your hands. If you must have some sort of movement going on to keep you from exposing a nervous tick, point and flex the tips of your toes

(if they're not visible to your interviewer). Meanwhile, engage the interviewer with plenty of eye contact, and smile a lot. Try to embrace any small silences that come up; there's no need to fill every second with chatter; in fact, if you let enough time go by to begin to feel an awkwardness in the silence, it will make you seem more comfortable and confident.

Odds are they won't tell you on the spot if they're going to sign you: an open call makes for a busy day at an agency. You'll probably hear something like "we'll contact you if we're interested." Don't read too much into this; it could be a good sign.

There are some other things too that increase your chances of getting agency representation. One is prior modeling experience. Despite what their promotional materials say, agencies do tend to favor models with experience. This doesn't mean you need to freelance for years before approaching an agency; but busting your ass as a freelancer for 6 months to learn the ropes and get some experience can significantly improve your chances.

Of course, if you're already a successful freelancer, you will be in a strong negotiating position, because taking you on may bring the agency a pre-existing income stream.

If you're already represented, an agency might not want to bother with you until you can show that any exclusive contracts with your previous agency have been terminated. If you have non-exclusive representation with the first agency, whether you may seek additional representation elsewhere depends on the specific terms of your contract.

If you follow the steps outlined above, you've done all you can to get representation. If in the end they don't bite, brush it off and hit up the next agency. Keep going until you find the one that believes in you. After all, if they're not 100% sold on you, they're not going to give 100% to selling you.

Contracts

If you are offered a contract, make sure to check it out thoroughly, including with your lawyer. Make sure it includes a term (time span the contract is valid for), and that you're comfortable with how long or short that is. Also make sure it includes the exact amount of commission the agency is allowed to take for a booking fee. Ask yourself if the travel stipulations make financial sense. Be on the lookout for fees, fines, and mentions of withholdings or stipulations regarding work outside of the agency. Some such items are customary practice in the business, but it's not unheard-of for agencies to try to take advantage of inexperienced (or even experienced) models by slipping in something outrageous. It's never rude or un-businesslike to ask for a few days to review any contract before you sign it; if the agency objects to this, it isn't a place you want to work anyway. Don't forget to ask for your own copy of the contract once it's signed.

There are three main types of agency contracts: non-exclusive, exclusive, and mother agency representation. All of these can be either 100% legit or traps that can cost you loads of money and even any chance at a successful career. This is why it's extremely important not only to read every word of the document before you sign it, but also have your lawyer review it as well.

Non-Exclusive Contract

Non-exclusive agency contracts may sound ideal at first, because they technically allow you to be represented by the agency as well as do other work on the side; however, these contracts have their own problems. Agencies used to sign models non-exclusively only rarely; now, in an attempt to bolster their shrinking businesses they are doing it far too much. Many agencies are now so overloaded with girls, many of them inexperienced, that there is inevitably a temptation to take care of their exclusively represented girls

181

first before letting work trickle down to their hoards of non-exclusives. In an era of shrinking business, this means that a non-exclusive model may not be sent out to many castings. Likewise, any extra career-management the agency may be able to muster will go to the exclusively represented models.

Finally, some contracts, while titled "Non-Exclusive" actually provide in the fine print that you surrender almost all control of your modeling career to the agency. In this way, the agency is helping you to achieve all the disadvantages of both an exclusive and a non-exclusive contract.

Exclusive Contract

An exclusive contract will lock you in to the agency for a period usually ranging from one to three years. During that time you generally can't work in the same genres with other agencies in the same market. Before signing, you need to ask yourself whether this makes sense for your career. Does this agency have the ability to find you significantly more work than you could find on your own? Do they have a good reputation, and a good track record of landing reputable clients and significant campaigns? Are there already a zillion girls on their board that look very similar to you? Do they make their models do a lot of free work for their personal friends' companies or photography businesses? Are their models' marketing materials current and impressively designed and produced? Are their current models happy with their representation?

To answer this last question, it is legitimate to contact models currently signed with the agency to ask for their input. However, it's probably most productive to approach only models who are active on modeling websites that you also belong to, and to contact them via private messaging. Take whatever insight they're willing to give; they're doing you a favor by sharing it, and they could be putting their ass on the line if they say anything negative. Assure them from

the beginning that anything they say will be held in the strictest confidence.

Never sign with any "agency" that requires you to take "modeling classes," charges you inflated prices for their "house photographer" to take pictures for your book, or asks for money under some vague description like "handling fees" or "signing fees." It goes without saying that any inappropriate or unprofessional behavior by any agency employee is a flashing neon arrow pointing to the exit.

And again, be sure to go over any contract carefully with your lawyer.

Mother-Agency Representation

Mother agencies book work for their models in the same way other agencies do, but they also try to land them representation with larger agencies. They collect a regular commission (about 20%) from work the model gets directly through them, and also collect a smaller commission (10-15%) from any work the model acquires through any agency the mother agency has farmed her out to. You need to consider signing a mother agency contract carefully, including consulting with your lawyer.

Moving From Agency to Freelance

Some models may wish to keep working after losing or quitting their agency representation. If you have prior notice of your impending departure, you can sometimes use your agency status to position yourself for a running start in your freelance career. During the last six months of your agency contract, find an unobtrusive way to include your direct contact information on client paperwork (release forms, comp cards, etc.). This will make it easy for clients to contact you directly for work in the future.

On set, remember to wow them; this is more important now than ever. While at castings, identify everyone with any booking power, and file the information away. Keep up any personal friendships you may have

struck up with clients or photographers, and you can also send them an annual Christmas card that includes your contact information, and perhaps a picture to help them remember your look.

You should also study your agency bookers when you're in the office. Try to listen in as they wheel and deal on the phones. Observe how they market the girls through their comp cards, books, online boards, etc., as well as how they try to generate positive word of mouth. Notice which models seem to be getting sent out to more castings and pushed more forcefully onto the clients, and figure out why. Keep your eyes and ears open, and always strive to improve your knowledge and your performance.

About The Author

Christie Gabriel was born in Chicago, Illinois, and began modeling at the age of 18. She has been represented by such agencies as Elite and Irene Marie, and has modeled in all the major markets in the United States, as well as many in Europe, doing everything from posing for art classes to high fashion runway work. Her dozen years of experience as both a represented and freelance model makes her uniquely qualified to write about the modeling industry. She lives in Chicago with her husband and son.

Made in the USA
Las Vegas, NV
06 April 2021

20866985R00105